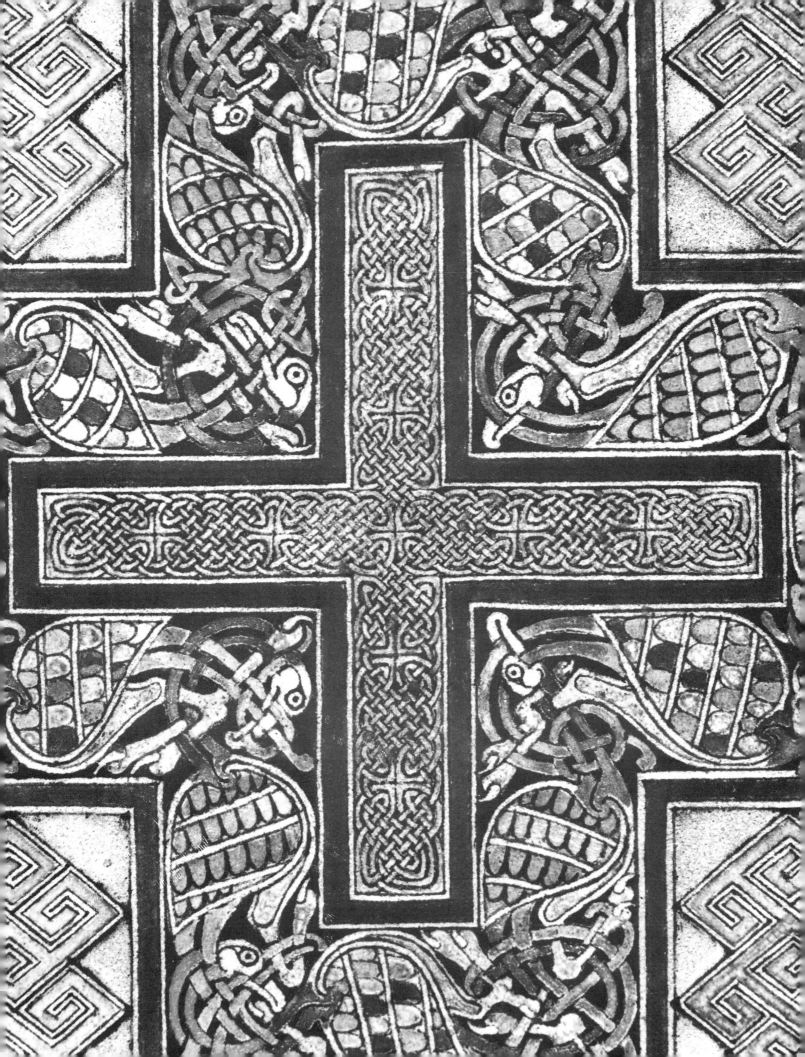

THE LINDISFARNE GOSPELS

JANET BACKHOUSE

A PHAIDON BOOK

CORNELL UNIVERSITY PRESS
ITHACA, NEW YORK

To the memory of
Professor Dame Lillian Penson
(1896-1963)

© 1981 by Phaidon Press Limited, Oxford

All rights reserved. Except for brief quotations in a review,
this book, or parts thereof, must not be reproduced in any
form without permission in writing from the publisher.
For information address Cornell University Press,
124 Roberts Place, Ithaca, New York 14850.

First published 1981 by Cornell University Press

International Standard Book Number 0-8014-1354-0
Library of Congress Catalog Card Number 81-65990

Printed and bound in Singapore under co-ordination
by Graphic Consultants International Private Limited

CONTENTS

ACKNOWLEDGEMENTS

The Lindisfarne Gospels is one of the most cherished treasures of the British Library, and many members of the staff of the Manuscripts Department have given help, both practical and academic, during the preparation of this book. I am particularly grateful to the Keeper of Manuscripts, Daniel Waley, for his enthusiastic encouragement of the project. I am also grateful to Bernard Dod and Freda Quartley of the Phaidon Press, who made the practical arrangements run so smoothly, and to Bruce Barker-Benfield, who read through the typescript and helped to clarify a number of points.

Thanks are due to Leslie Webster, Andrew Oddy and Judy Rudoe of the British Museum; Professor Rosemary Cramp of Durham University; Dr George Salt of King's College, Cambridge; Canon A. N. Barnard of Lichfield; Canon R. L. Coppin of Durham; Revd. D. A. Bill of Holy Island and Revd. I. D. Bunting of Chester-le-Street, for information on particular points and for help in obtaining photographs. Sources of photographs are included in the captions; those for which no source is given were supplied by the British Library's photographic service.

Special thanks go to Lawrence Pordes, senior photographer in the British Library, for his skill and patience in making a new set of photographs of the manuscript, many of which are used here; and to Shelley Jones, who has been very much involved with the subject from the beginning, and with whom I visited the manuscript's three medieval homes, Saint Cuthbert's hermitage on Farne Island, and many other sites and monuments in Anglo-Saxon Northumbria.

1. LINDISFARNE AND SAINT CUTHBERT

The Lindisfarne Gospels (British Library, Cotton MS Nero D.iv), made in north-east England less than a century after the introduction there of Christianity and now rapidly approaching its 1,300th birthday, is one of the world's greatest masterpieces of manuscript painting. Fortunately for the many generations of scholars and art lovers who have studied and admired it, it is also one of the best documented. About the middle of the tenth century a priest called Aldred, who had added to it an Anglo-Saxon translation of the Latin text, wrote on the last leaf a colophon naming the four men who made it, including himself. Although the book was already some 250 years old, Aldred was certainly recording well-established tradition, and there is no reason to doubt his statement. In modern English the colophon reads:

> Eadfrith, Bishop of the Lindisfarne Church, originally wrote this book, for God and for Saint Cuthbert and — jointly — for all the saints whose relics are in the Island. And Ethelwald, Bishop of the Lindisfarne islanders, impressed it on the outside and covered it — as he well knew how to do. And Billfrith, the anchorite, forged the ornaments which are on it on the outside and adorned it with gold and with gems and also with gilded-over silver — pure metal. And Aldred, unworthy and most miserable priest, glossed it in English between the lines with the help of God and Saint Cuthbert....

The monastery of Lindisfarne, where Eadfrith and Ethelwald were bishops, was founded in or about AD 635 on a small outcrop of land, now known as Holy Island, lying among the sands about a mile and a half off the Northumberland coast and 12 miles south of Berwick-upon-Tweed (plate 1). The site is marked by the ruins of a later medieval priory, founded about 1083 as a dependency of Durham Cathedral Priory (plate 2). Today about 200 people live on Holy Island, most of them making a living either from fishing or through some aspect of the tourist trade, which every year brings thousands of visitors to their village. The modern causeway has a metalled surface, but until very recently residents and visitors alike were still obliged to follow a track across the sands, exactly as medieval pilgrims had done. Twice each day, for several hours at a time, the island is cut off from the mainland by the sea, which means that everyday matters such as postal deliveries and bus timetables are governed by the movements of the tide. To the members of the seventh-century monastic community the situation must have seemed ideal, the sea providing a visible barrier between them and the world (and at least a partial defence against attack from the land), without entirely hindering them in their comings and goings as missionaries and preachers in other parts of the kingdom of Northumbria.

The first Christian mission to the Anglo-Saxon population of Northumbria was undertaken by Saint Paulinus, one of a group of

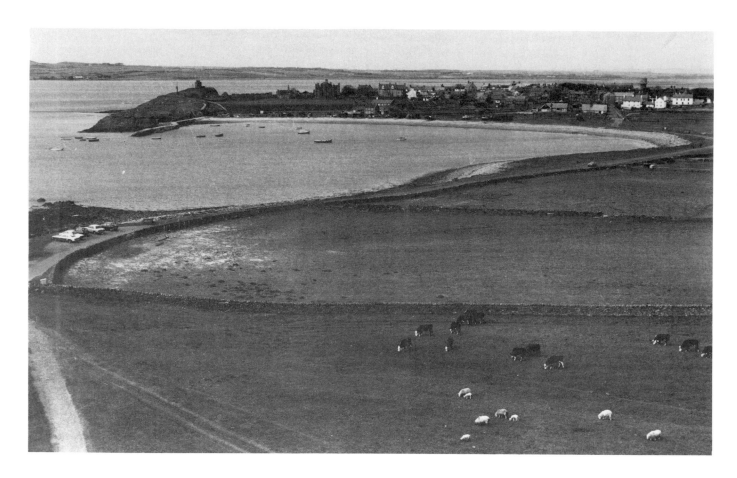

men sent from Rome to England in 601 by Pope Gregory the Great to assist in the work of conversion already begun in Kent by Saint Augustine. Paulinus came north in 625 as chaplain to the Christian Princess Ethelberga of Kent, bride of King Edwin of Northumbria, and his preaching, supported by the conversion of the king, met with great success. However, Edwin's death in battle in 633 resulted in a resurgence of paganism, and Paulinus and Ethelberga fled back to the south. Two years later King Oswald, eager to re-establish the new faith, sent to the Irish monastery on Iona for priests. A fresh mission was led by Saint Aidan, and it was he who founded the monastery on Holy Island, conveniently close to his royal patron's stronghold on the rock of Bamburgh, which is clearly visible from Lindisfarne. Saint Aidan and his companions travelled the length and breadth of Northumbria, usually on foot, preaching and baptizing. By the time of Aidan's death in 651 the Christian faith was firmly established in the area and several further monastic communities had been founded.

Saint Cuthbert, in whose honour the Lindisfarne Gospels was to be made, was born about the time of the arrival of the missionaries from Iona. We know a great deal about him because, only a few years after his death, two detailed accounts of his life were written. The first was by an anonymous monk of the Lindisfarne community and the second, in part based upon it, was by the Venerable Bede, the 'father of English history', who died in 735. Both men were able to include material gathered from people still living who had known Saint Cuthbert well. He seems to have been a warm-hearted and practical person, and many of his miracles involve delightful animal stories.

Cuthbert entered the monastery of Melrose, in what is now lowland Scotland, soon after Saint Aidan's death, which he had seen in a vision while caring for sheep in the Lammermuir Hills. After a period of study under Boisil, the saintly prior of Melrose, he was ordained priest

1. Present-day view of the village and harbour of Holy Island. The ruins of Lindisfarne Priory stand between the houses and the promontory and harbour wall (*photo: the author*).

8

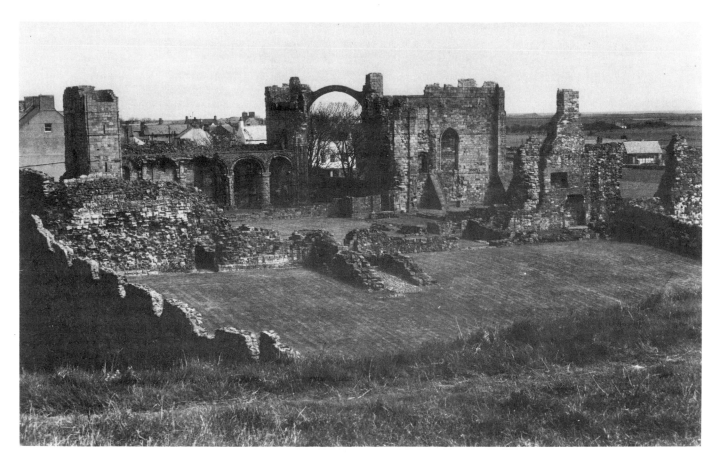

2. The ruins of Lindisfarne Priory, built probably on the site of the Anglo-Saxon monastery. The Priory was founded about 1083 as a dependency of Durham Cathedral Priory, and the massive decorated columns of the ruined church are very similar to those in Durham Cathedral itself (*photo: the author*).

and began to journey about Northumbria, preaching and administering the sacraments, and rapidly acquiring a reputation for holiness and for the possession of miraculous powers. He spent a short period at Ripon, where he helped to found a new monastery, succeeded Boisil as prior of Melrose, and was eventually sent to Lindisfarne to reform the way of life of the community, as discipline there had become slack. At Lindisfarne Cuthbert found himself more and more attracted to the idea of a life of solitude. He began by withdrawing occasionally to a tiny islet only a few yards off the shore of the main island and, like it, accessible on foot at low tide. Later he moved to Farne Island, directly opposite Bamburgh, where he built himself a hermitage from which he could see nothing but the sky. There he lived alone for a number of years, visited not only by the monks of his own community but also by many people from far and near who had been attracted by his growing reputation for saintliness. In 684, after King Ecgfrith himself had visited the island to plead with him, Cuthbert bowed to pressure to accept election as a bishop, and the following Easter he was consecrated at York by Archbishop Theodore of Canterbury.

For the short space of two years Saint Cuthbert returned to his earlier itinerant life. Then, feeling that the end of his life was approaching, he returned to his hermitage on Farne Island. One of his last miracles, used by Bede to demonstrate the virtue of obedience, kept a group of monks from Lindisfarne imprisoned on the island by a storm for an entire week because they had neglected to obey his instructions to cook and eat a goose hanging ready in his little guest house (plate 3). He died on 20 March 687, attended at the last by a small group of his brethren, and his passing was signalled across the sea to Holy Island by the waving of torches.

Cuthbert himself realized that he would be venerated as a saint and that his tomb would quickly attract pilgrims. He would have preferred

a simple grave on Farne Island, where he had a sarcophagus and a winding sheet in readiness, but he yielded to the wishes of the community and agreed that his body might be taken to Lindisfarne for burial. It was usual for the remains of a holy man to be left in the earth long enough for the soft parts of the body to disintegrate, and then for the bones to be raised, washed, wrapped in fine cloths, and placed in a casket above ground where they could be visited by the faithful. This 'elevation' of the relics amounted to a formal declaration of sainthood. Eleven years elapsed before Cuthbert's successor, Eadbert, gave his consent for the grave to be reopened. In the meantime a new roof of lead was placed on the monastery's wooden church, a carved oak chest was made to receive the relics, and, almost certainly also during this period, the Lindisfarne Gospels itself was written and illuminated. At last, in 698, on the anniversary of Cuthbert's death, the grave was opened to reveal a body miraculously undecayed, in further proof of holiness (plate 4). It was reverently placed in its casket and laid on the floor of the sanctuary. As Cuthbert had foreseen, pilgrims flocked to the shrine and miracles were soon recorded.

In 793, apparently without warning, Lindisfarne was raided and sacked by Vikings. Writing from the court of Charlemagne to King Ethelred of Northumbria, Alcuin of York exclaimed: '... never before has such terror appeared in Britain as we have now suffered from a pagan race, nor was it thought that such an inroad from the sea could be made.' Although the community soon returned to the island, it was

3. The miracle of the uncooked goose. An illustration from a copy of Bede's prose Life of Saint Cuthbert, written and decorated at Durham Cathedral Priory about 1100–20. University College, Oxford, MS 165, p. 98 (*Bodleian Library, Oxford*).

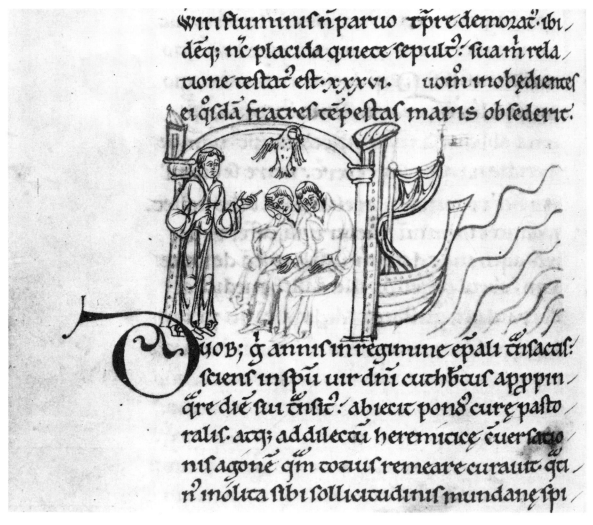

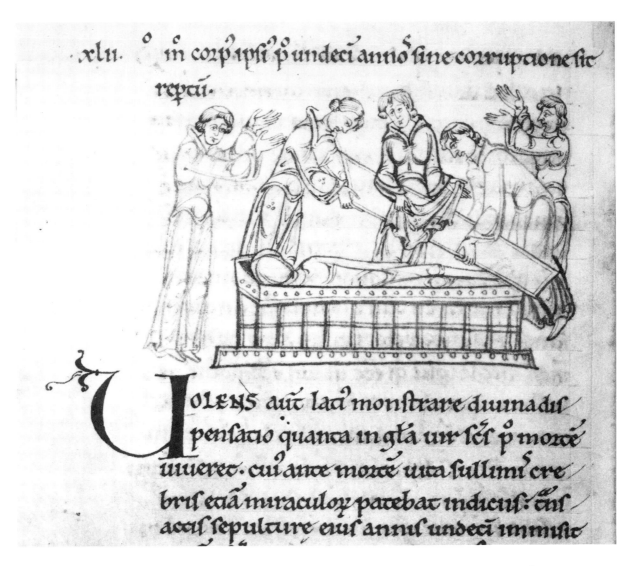

xlii. o in corp ipsi p undeci anno sine corrupcaone sic reptui.

UOLENS aut lacu monstrare diuina dis pensacio quanta in gla uir scs p morcē uiueret. cui ante morcē uita sullimi cre bris eciā miraculoy patebat indicus: cū accis sepulture eius annis undeci immisit

4. The opening of Saint Cuthbert's grave in 698. The monks display their astonishment at finding his body miraculously undecayed. University College, Oxford, MS 165, p. 118 (*Bodleian Library, Oxford*).

with an increasing sense of unease as monastery after monastery suffered the same fate. At last, in 875, Bishop Eardulf took the relics of Saint Cuthbert and other treasures of the monastery, including the Lindisfarne Gospels and the bones of the two men who had made it, his predecessors Eadfrith and Ethelwald, and set off in search of a safer home. He was accompanied by all the inhabitants of the island, seven of whom were given special charge over the relics. Their wanderings, chronicled at the beginning of the twelfth century by Symeon of Durham, lasted about seven years. There was a time when it seemed that their final destination would be Ireland, but we are told that, as the bishop and his party tried to put out to sea, a terrible storm arose, three great waves swept over the ship and were turned to blood, and a copy of the Four Gospels, richly bound in gold and jewels, was swept overboard and lost. This was taken as a sign of the saint's displeasure, and the voyage was immediately abandoned. Saint Cuthbert then appeared in a dream to Hunred, one of the seven bearers, and told him where the manuscript could be found, washed up unharmed on the sands at a low tide. According to Symeon of Durham, the manuscript was the Lindisfarne Gospels.

Not long after this episode, the party settled at Chester-le-Street, in County Durham, where Saint Cuthbert's relics remained until 995, and it was there that Aldred the priest added his Anglo-Saxon gloss and colophon to the manuscript, probably during the third quarter of the tenth century.

2. THE MEN WHO MADE THE MANUSCRIPT

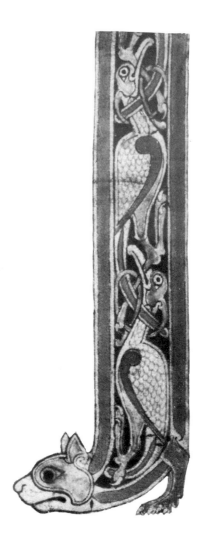

Four men are named in Aldred's colophon (plate 5) as contributors to the making of the Lindisfarne Gospels. The first is Bishop Eadfrith of Lindisfarne, who succeeded Bishop Eadbert in 698, shortly after Saint Cuthbert's elevation. He is said to have written the manuscript. The second, credited with binding it, is Bishop Ethelwald of Lindisfarne, who succeeded Eadfrith in 721. The third is Billfrith the Anchorite, who provided ornaments of gold, silver and jewels for its outer casing. The fourth is Aldred himself, who inserted the Anglo-Saxon translation or gloss.

Nothing is known of Eadfrith before he became bishop of Lindisfarne in May 698, except that he was apparently a member of the Lindisfarne monastic community. There are, however, several references to his activities after that date. Both the anonymous Life of Saint Cuthbert by one of the monks of Lindisfarne and the prose Life by the Venerable Bede are addressed to him. Eadfrith honoured Bede in return by promising that his name should be inscribed in the Lindisfarne *Liber Vitae* or *Book of Life* by Guthfrith the sacrist, and that he should be remembered in the prayers of the community. The original *Liber Vitae* kept by Guthfrith is no longer in existence, but a magnificent copy in letters of gold and silver was made about the middle of the ninth century. This is now in the British Library (Cotton MS Domitian A.vii) and Bede's name indeed appears in it, on folio 18b. In the prose Life, Bede refers to the restoration of Saint Cuthbert's hermitage on Farne Island by Eadfrith for Felgild, the saint's second successor there. From another eighth-century work, a Latin poem known as the *De Abbatibus*, by a monk called Ethelwulf, we learn that Eadfrith also gave advice and assistance in the foundation of Ethelwulf's own monastery, the history of which the poem recounts but the name of which unfortunately we do not know.

Ethelwald makes several appearances in Bede's *Ecclesiastical History* as well as in the Lives of Saint Cuthbert. As a young novice, he had been in personal attendance upon the saint, and he was witness to one of Cuthbert's miracles, when one of his own kinswomen was cured of an intolerable pain affecting her head and one side of her body. Soon after the elevation of the saint's relics in 698 he moved from Lindisfarne to Melrose, where he remained, first as prior and then as abbot, until shortly before he succeeded Eadfrith as bishop in 721. He died in or about 740 and was buried on Lindisfarne at the foot of a large stone cross which he himself had erected. This was later to be removed to Durham.

Of Billfrith's life nothing at all is known, except that he was an anchorite, or hermit, as Saint Cuthbert himself had been. He was also a priest. His name appears at the head of the second column on the page devoted to anchorites in the Lindisfarne *Liber Vitae* (folio 15), and its position in relation to other known names suggests that he probably

died during the latter part of the eighth century. The high regard in which anchorites were held is reflected in the fact that only two classes of people, both largely of royal blood, are placed before them in the *Liber Vitae.*

The wording of Aldred's colophon is not entirely unambiguous and there has been much discussion about its exact meaning. Some scholars have argued that Eadfrith and Ethelwald did not themselves make the manuscript but merely commissioned someone else to do so. However, Symeon of Durham, writing in the early twelfth century but with the full weight of local tradition behind him, says quite categorically that Eadfrith wrote the book with his own hand.

5. The Anglo-Saxon colophon added to the manuscript by Aldred in the mid-tenth century. It names Eadfrith, Ethelwald, Billfrith and Aldred himself as the four contributors to the making of the manuscript. A translation is given on p. 7 above. The Lindisfarne Gospels, folio 259 (detail).

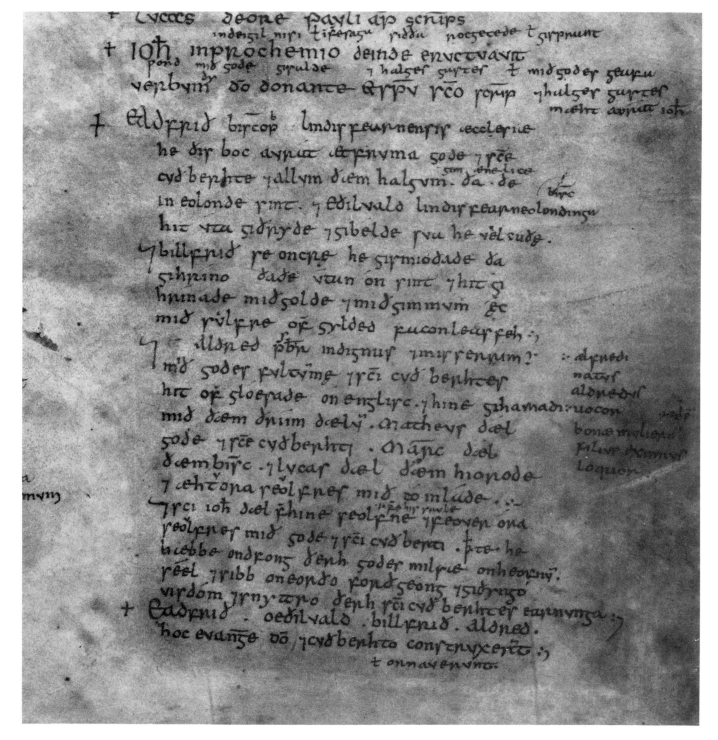

The careful examination of the manuscript made when the facsimile edition was published 25 years ago showed clearly that, with the exception of the rubrics and some contemporary corrections and additions to the text, the whole of the Gospels had been written out by a single scribe. Furthermore, the decoration is so closely linked to the writing, particularly in one or two places where the original scheme was sketched out and then changed before the page was finished, that it must have been the work of the scribe himself. The examination also suggested that the book had been designed and made in a single campaign, without major interruption, and that it probably took at the very least two years to complete. This may be a considerable underestimate, as we do not have details about matters such as the weather. In 764 the Abbot of Wearmouth–Jarrow wrote to a friend, blaming an exceptionally cold winter for his scribe's inability to complete some books.

It seems unlikely that Eadfrith would have had the leisure to undertake a major artistic task of this kind after his election as bishop, when his life no doubt took on the strenuous pattern of travelling and preaching familiar from that of Saint Cuthbert. It is much more likely that he made the Gospels in the period immediately before the elevation of the relics in 698, when he was still only a senior member of the community, possibly head of the monastic scriptorium. Talented scribes and illuminators were held in very high esteem. Saint Columba, founder of Iona, was particularly noted for his activities as a scribe, and the *De Abbatibus* includes an account of an Irish monk called Ultan whose hand, 'once used to write the Lord's word', performed a miraculous cure as his bones were being raised from their original resting place. A senior monk who was also a talented scribe might well have been seen by his brethren as the most suitable candidate for election as bishop.

The known facts of Ethelwald's career also point to a date before 698 for the making of the Gospels. Immediately before the elevation he too was apparently only a senior member of the Lindisfarne community, but sometime between 699 and 705 he moved from the island to Melrose, not returning to Lindisfarne until 721. It thus seems sensible to suppose that he bound the manuscript before his departure, but the binding has long since disappeared. One single leather book binding made in Northumbria at this date has survived, the earliest European binding still associated with the manuscript for which it was made. This is the binding of the Saint Cuthbert Gospel, an exquisite little copy of the Gospel of Saint John which was found in Saint Cuthbert's coffin when his relics were translated to their new resting place in Durham Cathedral in 1104. The Gospel, which is at present on loan to the British Library, was copied in Bede's community of Wearmouth–Jarrow and may perhaps have been a gift to Lindisfarne in honour of the elevation. The binding is of crimson goatskin over beechwood boards, and the raised decoration on the front cover is moulded over cords (plate 6).

The exact form of Billfrith's contribution will never be known, for with Ethelwald's it disappeared centuries ago, probably at the Reformation. It was not uncommon for precious decoration to be added to the bindings of special Gospel books. Symeon of Durham's account of the Lindisfarne Gospels suggests that Billfrith's work was carried out at the request of Ethelwald whilst he was Bishop (721-40). No English jewelled binding of so early a date survives, but the silver plates added to Saint Cuthbert's portable altar presumably date from 698 and are therefore contemporary (plate 7).

6. The contemporary binding of the late seventh-century Saint Cuthbert Gospel (also known as the Stonyhurst Gospel), found in the coffin of Saint Cuthbert at the time of his translation in 1104, and at present on loan to the British Library (*by permission of the English Province of the Society of Jesus*).

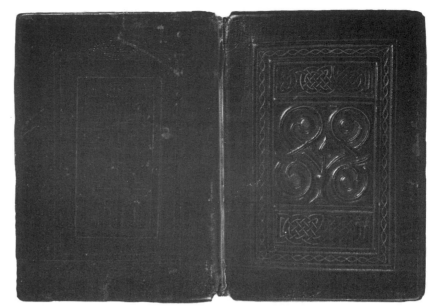

7. Fragments of silver ornaments from the back of Saint Cuthbert's portable altar. The fragments bearing foliate ornament probably date from the time of the elevation of the relics in 698. The decorated central patch is a ninth-century repair. The altar was found lying on Saint Cuthbert's breast when his tomb was opened in 1827 (*Durham Cathedral Library*).

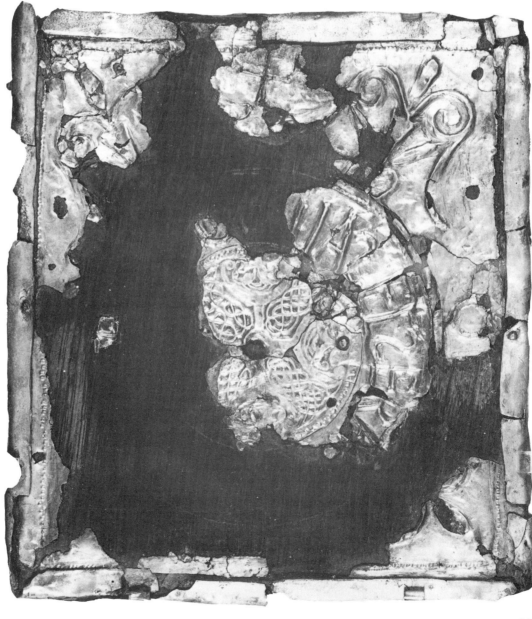

15

Personal information about Aldred himself is also scanty. His father, according to a marginal note beside the colophon, was called Alfred. Two other manuscripts have additions which have been recognized as by his hand. One is the oldest surviving copy of Bede's Commentary on the Book of Proverbs (Bodleian Library, Oxford, MS Bodley 819; plate 12), written in the Wearmouth–Jarrow scriptorium in the second half of the eighth century and known to have been at Durham in the twelfth. The other, which reveals that Aldred advanced to be provost of Chester-le-Street, is the so-called Durham Ritual (MS A.IV.19 in Durham Cathedral Library), a collection of liturgical material probably written out in the south of England in the early tenth century, to which Aldred added (on page 167) four collects in honour of Saint Cuthbert. The collects are accompanied by a note recording that they were written out for Bishop Aelfsige by Aldred the Provost, at a place called Oakley, on a feast of Saint Lawrence which was also the fifth night of the moon. Aelfsige was bishop of Chester-le-Street between 968 and 990, and the feast of Saint Lawrence (10 August) coincided with the fifth night of the moon in 970. Oakley appears to be identifiable as a place in Wessex, on the road between Salisbury and Blandford. It seems likely that Aelfsige, accompanied by Aldred, was in attendance upon King Edgar at the appropriate time.

In the Lindisfarne Gospels colophon, which must be earlier than the note in the Durham Ritual because in it Aldred describes himself only as a priest, he goes on to tell us that each Gospel was glossed with a separate special intention. Matthew was for God and Saint Cuthbert, Mark for the bishop, Luke for the community (with the addition of eight 'ores' of silver for his induction), and John for the sake of his own soul (with four 'ores' of silver for God and Saint Cuthbert). This suggests that his work on the manuscript was intended to establish him in the community at Chester-le-Street. It probably dates from shortly after the middle of the tenth century.

3. THE TEXT OF THE GOSPELS

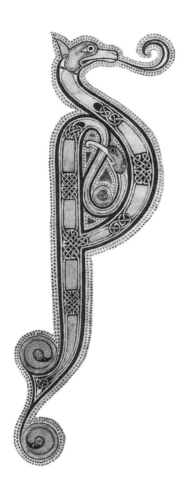

OVERLEAF:
8. A page from Saint Matthew's Gospel, including the beginning of the Sermon on the Mount (Matthew 4: 24–5: 10). Aldred's tenth-century gloss, a word for word translation of the Latin, is added between the lines and in the right-hand margin. The Lindisfarne Gospels, folio 34.

9. A page from the table of feast days preceding Saint John's Gospel. Aldred added little to this page, so the full beauty of Eadfrith's script can be appreciated without distraction. The headings are in a different hand, that of the rubricator. The Lindisfarne Gospels, folio 208.

The Lindisfarne Gospels contains not one but two versions of the Gospel texts. The first is the Latin copied out by Eadfrith and and the second the Anglo-Saxon interlinear gloss added two and a half centuries later by Aldred. Aldred's gloss is of great interest to students of English because it represents the earliest surviving translation of the Four Gospels into any form of the English language. It is a literal translation, written word by word between the lines of the Latin text, with occasional passages in the margins (plate 8). There is no necessity to assume that Aldred himself composed it. His colophon quite probably implies that he copied it from some other source which has not come down to us. There is indeed a very similar gloss in the MacRegol Gospels, an early ninth-century Irish manuscript now in Oxford (Bodleian Library, MS Auct. D.2.19), and it is probably not much later in date than Aldred's work. A surprising quantity of Anglo-Saxon literature — original poetry and prose as well as translations of Latin texts — has survived in manuscript. Although a great deal more has doubtless disappeared, England can still boast the richest vernacular literature in Europe from so early a date. It is only necessary to recall that something as celebrated as the *Beowulf* poem is known only from a single copy (British Library, Cotton MS Vitellius A.xv), itself badly damaged as recently as 1731, when it was one of the casualties of the fire which destroyed a considerable portion of the Cotton library, to realize just how vulnerable such material can be.

We know of at least one eighth-century translation of the Gospel of Saint John, though it apparently has not survived. The Venerable Bede was working on it at the time of his death in May 735, and its final sentence was the last thing which he dictated to Wilberht, his young amanuensis.

The Latin Gospel text is that of Saint Jerome's Vulgate, a revision of the Latin Bible made in the late fourth century and subsequently the most widely adopted throughout the western world. In the Lindisfarne Gospels it is preceded by the text of Saint Jerome's letter to Pope Damasus, at whose command the revision had been carried out, by the prologue to Saint Jerome's commentary on Matthew, and by a series of Eusebian canon tables (see below, p. 41), prefaced by the explanatory letter of Eusebius to Carpianus. At the beginning of each of the Gospels is a short introduction ('argumentum'), a list of passages used as liturgical readings ('capitula lectionum') and a list of festivals on which passages from that particular Gospel should be read (plate 9). The last item has no practical value, as details of the passages concerned are not included in it. It is, however, of special interest, as references to Saint Januarius in the lists preceding Matthew and John, and to the dedication of a basilica of Saint Stephen before Matthew, reflect a connection with Naples, suggesting that Eadfrith's exemplar was a Gospel book imported into England from the south of Italy.

t ᵹerenaᵹ
7 ᵹeeude meᵹunᵹ hir
ET ABIIT OPINIO EIUS
mulle ᵹynia
IN TOTAM SYRIAM
7 ᵹebrohton hm alle
ET OBTULERUNT EI OMNES
ða yþle hæfdon
MALE HABENTES
midmonig ᵹælдᵹ unhælo
UARIIS LANGUORIBUS
7 mið fiondᵹelđu 7 mið tortunᵹum
ET ORMENTIS
beᵹena 7 ᵹenumena
COMPREHENSOS
ða dioblet
ET QUI DAEMONIA
hæfdon 7 bræcrec
HABEBANT ET LUNATICA
7 tond cryplar
COS PARALIT ACOS
7 ᵹebota hea
ET CURAUIT EOS
7 ᵹefylᵹdon hine
ET SECUTAE SUNT EUM
ðreate moniᵹu
TURBAE MULTAE
of ᵹalilea 7 of ðeonbyriᵹ
DE GALILAEA ET DE CAPO
7
LIM ET HIEROSOLIMIS
7 of iudea 7 of
ET DE IUDAEA ET DE
bihonda iordanen
TRANS IORDANEN
ᵹeseh þæоðlice ðreatas
UIDENS AUTEM TURBAS
ᵹeras in mon
ASCENDIT IN MONTEM
7 mið ᵹesæte ᵹeneolecton
ET CUM SEDISSET ACCESSE
to him
RUNT AD EUM
ðeᵹnar his
DISCIPULI EIUS
7 untynde muð hir
ET APERIENS OS SUUM
ᵹe lærde hea cuoeð
DOCEBAT EOS DICENS

bidon o trno
eudᵹe ða ðærfendo oᵹsarce eudᵹe bidon ða
BEATI PAUPERES SPU *ðæppoe þir un*
fдon miora ys tun synniᵹo
QUONIAM IPSORUM EST *ðon hia aᵹan ᵹoder*
inc heorna
REGNUM CAELORUM
eudᵹe bidon ða milde fдon
BEATI MITES QUONIAM *fдon ða milde*
ða aᵹneᵹað ᵹbr er hlᵹiende
IPSI POSIDEBUNT *condo*
þordo
TERRAM
eudᵹe bidon ða ᵹemenar nu
BEATI QUI LUGUNT *hunc*
fдon ða
QUONIAM IPSI
ᵹefrnoerned bi ðon
CONSOLABUNTUR
eudᵹe bidon ða hyneᵹnuð eudᵹe bidon
BEATI QUI ESURIUNT *ða de ᵹ hyneᵹnar*
7 ðyrtaᵹ roðrætenyre efti roðreort
ET SITIUNT IUSTITIAM *nyrt fдon ða*
fordon ða ilco ᵹefyllд bidon
QUONIAM IPSI *mece lif.*
ᵹefylleð bidon t ᵹemerded
SATURABUNTUR
eudᵹe bidon milдheorte
BEATI MISERICORDES
fдon miora t ða
QUONIAM IPSI
mildheortnyᵹe
MISERICORDIAM
hm ᵹefylᵹer
CONSEQUENTUR
eudᵹe bidon claene of hearte eudᵹe bidon ða
BEATI MUNDO CORDE *tmo claene hearte*
fordon ða sod burte eruce
QUONIAM IPSI DM *7 ᵹeþoeleum ræne fдon*
ᵹereᵹ ma ᵹefeaᵹ
UIDEBUNT *sod in ecnyre*
eudᵹe bidon ᵹifume t ᵹnidᵹeonne
BEATI PACIFICI *eudᵹe bidon*
fordon ða yuna ða ᵹnidᵹeonne
QUONIAM IPSI FILII *ðaðe hea burta*
ᵹoder ᵹeeniᵹ bidon t ᵹenemned 7ᵹeþoeleum ᵹelrta
DI UOCABUNTUR *troᵹe behuldar*
eudᵹe bidon ðaðe oehtinᵹe ða yne þoder sun
BEATI QUI PERSECUTIO *ᵹenemned*
nem

þridda bebeadande
TERTIO COMMENDANS
mid hreacing honda
EXTENSIONE MANUUM
rahte ł him þte nodes
SIGNIFICAT EI QUOD CRUCIS
deade uenetoyband mid drohnge
MORTE FORE MARTYRIO
sy isfert nad
CORONANDUS

quae lectio cum in natale
sci petri legitur.
a loco in coetur
quo ait

Dixit simoni
petro ihs simon
iohannis
diligis me plus his
usq: ad locum ubi dicat
significans qua morte
clarificaturus esset dnm
cum uero in natale sci
iohannis euangelistae in
choanda est a loco quo
ait dicat ei hoc est dns
simoni petro sequere me
usq: ubi dicat &scimus
quia uerum est
testimonium eius

explicit secundum
iohannem
Sci iohannis
apostoli &
euangelista
post epiphania
dnica prima
post ephipania dnica
secunda
Inuelanda
In dedicatione sce mariae.
Dnica .ii. xlgesima paschae.
post octabas dni in ihu xpi.
post .iii. dnicas de epiphania
de muliere samaritanae.
De xlgesima feria .iiii.
In sci angeli & in dedicatione
domus
Coticiana
in natale sci andreae.
Coticiana
post .iiii. dnicas xlgesima
feria .iiii.
post .iiii. dnica xlgesima feria
.iiii.

The most likely source for such a manuscript in seventh-century Northumbria is undoubtedly Wearmouth–Jarrow. The early Church in England did, however, have a long and consistent connection with Italy and the Mediterranean. The first missionaries to the Anglo-Saxons, Saint Augustine of Canterbury and his followers, came direct from Rome on the orders of Pope Gregory the Great. They brought books with them, and further books were subsequently dispatched from Rome with those who, like Saint Paulinus, were sent in later years to reinforce the mission. Books reputed to have belonged to Saint Augustine were preserved as relics at Canterbury in the later Middle Ages, and what is almost certainly one of these, an illuminated copy of the Four Gospels, is still in existence (Corpus Christi College, Cambridge, MS 286). It dates from the sixth century and was written and decorated in Italy. One of Saint Augustine's successors as archbishop of Canterbury was Theodore of Tarsus, who had been a monk in Rome before coming to England in 669. He was accompanied by another monk, Hadrian, who had been born in Africa but whose original monastery was in Campania, not far from Naples. Hadrian was appointed abbot in Canterbury. Both these were learned men who attracted many students and who had doubtless brought further manuscripts with them to England.

In Northumbria during the first decades after the conversion, inspite of the initial Roman impetus of Saint Paulinus, the closest external links were with Ireland through Iona. However, after the Synod of Whitby in 664 had settled the disagreement over the calculation of the date of Easter in favour of Roman rather than of Irish custom, with the result that many Celtic diehards withdrew from Northumbrian communities, direct links between Northumbria and Italy grew stronger. One personality whose activities had considerable influence was Saint Wilfrid of York (634-709), who had already made one journey to Rome before appearing at Whitby to represent the Roman case. He was to go there twice more in the course of his long and turbulent episcopal career, and we know that he took a great interest in books and in learning.

Most significant of all in this context are the careers of Benedict Biscop, who founded the monastery of Saint Peter at Wearmouth in 674, and of his friend and successor Ceolfrith, to whom he entrusted the establishment of the sister house of Saint Paul at Jarrow in 681. It was at Jarrow that the Venerable Bede spent almost the whole of his life. Benedict Biscop, who came of a noble Northumbrian family, had already been more than once to Rome before he settled at Wearmouth. He made two further visits, one of them in Ceolfrith's company, in order to bring back books, relics and works of art for his twin foundations. Unfortunately, none of his acquisitions have survived, but we know that the books which he collected included fine texts written in Italy in the sixth century, outstanding amongst which were the Codex Grandior, a vast copy of the whole of the Bible, and some or all of the Novem Codices, a Bible in nine volumes, all of which had been made at Cassiodorus's monastery of Vivarium in the extreme south of Italy. The work of the scriptorium at Wearmouth–Jarrow was very much influenced by the script and appearance of these manuscripts, which were emulated there with great success.

Contact between Lindisfarne and Wearmouth–Jarrow, only 40 miles apart, seems to have been close during the late seventh and early eighth centuries. As we have already seen, Eadfrith, creator of the Lindisfarne Gospels itself, asked Bede to compose a Life of his own monastery's special saint, Cuthbert. The names of both Benedict

Biscop and Ceolfrith, like that of Bede, appear in the Lindisfarne *Liber Vitae* (on folios 17 and 15b respectively). The Gospel text which Eadfrith copied could well have been borrowed from Wearmouth–Jarrow and, indeed, textually the Lindisfarne Gospels has close relatives in the two most famous of the Wearmouth–Jarrow manuscripts, the Codex Amiatinus (Biblioteca Medicea-Laurenziana, Florence, MS Amiatinus I) and the Saint Cuthbert (or Stonyhurst) Gospel of Saint John. These are the three leading members of a distinct family of manuscripts, the so-called 'Italo-Northumbrian' group, which is one of the most important sources for the early form of the Vulgate text.

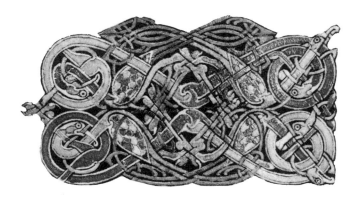

4. THE SCRIPT

Eadfrith chose to write the main text of his Gospels in the fine formal script known technically as insular majuscule (plates 8 and 9). The manuscript which he was making was intended not for the use of students in a library, but for ceremonial use in church, where it would be carried in procession and used for reading, perhaps not every day but certainly on special festivals. Its place would be with the altar vessels rather than with any other books that the monastery might possess. Every effort was therefore made to ensure that the final effect, both inside and out, should be in keeping with the status of a book enshrining the Word of God.

The insular majuscule script was developed in early Christian Ireland, whence it spread to Northumbria, through Iona and the Irish missionaries, and was subsequently adopted in other parts of England. As its name suggests, it was a speciality of the British Isles, but it is also found on the Continent, in areas influenced by Irish and English monastic foundations such as Bobbio, Sankt Gallen, Fulda and Echternach. Insular majuscule appears in a number of manuscripts earlier in date than the Lindisfarne Gospels, including the Book of Durrow (Trinity College, Dublin, MS 57; plate 53), but Eadfrith's interpretation of it is particularly stately, regular and disciplined. He wrote it with fairly broad nibs, cut to a remarkably consistent width throughout the execution of the text, and held parallel to the double guide lines which he ruled upon the page. The result is well-balanced and majestic, and was probably in some degree influenced by the appearance of Wearmouth–Jarrow books of the same date, even though these are not written in insular majuscule.

The script most characteristic of the Wearmouth–Jarrow scriptorium was uncial, a formal capitular hand developed in the Roman Empire during the fourth century and widely used for several centuries thereafter for writing out texts in book form. The manuscripts brought to England by Saint Augustine and his followers and those later collected by Benedict Biscop and Ceolfrith provided English scribes with many fine models for this script. So brilliantly did the scribes of Bede's community learn to execute it that the surviving masterpiece from Wearmouth–Jarrow, the huge one-volume Bible known as the Codex Amiatinus, now in Florence, was only recognized as English work within the last century, after much disagreement among scholars. Some of them, while eventually accepting that the book had been made in Northumbria, still refused to believe that it was not the work of immigrant Italian scribes. Only in recent years has the special flavour of 'English uncial' come to be discerned more easily. The Codex Amiatinus, like the Lindisfarne Gospels, is, however, unusually well documented. The anonymous author of the *Historia Abbatum*, who tells the story of the early abbots of Wearmouth–Jarrow, relates how Abbot Ceolfrith ordered three great

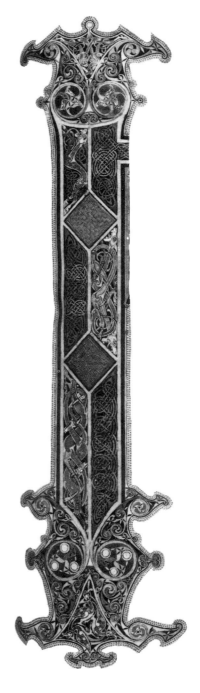

Bibles to be made, one for Wearmouth, one for Jarrow and the third to be presented to the Pope. The third copy he took with him when he left Northumbria to make a final pilgrimage to Rome in 716. He died on the journey and we do not know exactly what then became of the manuscript, but it is identifiable beyond doubt as the Codex Amiatinus because Ceolfrith's dedicatory inscription to the Pope, quoted in the *Historia Abbatum*, is still to be seen in it. The book reached Florence in 1787, when the monastery of Monte Amiato was suppressed and its library removed. Fragments of one of the other Ceolfrith Bibles have been discovered, re-used as wrappers for volumes of estate papers, and these are now in the British Library (Additional MS 37777 (plate 10), and Additional MS 45025).

The layout of the Ceolfrith Bibles' leaves and the layout of Eadfrith's text pages are certainly similar (though the Bibles are much larger), and it seems reasonable to suppose that Eadfrith decided to write his Gospels in two columns because he had seen earlier Italian books and their Wearmouth–Jarrow counterparts. His is not the only insular Gospel book to be laid out in this way. The virtually contemporary Echternach Gospels (Bibliothèque Nationale, Paris, MS lat. 9389; see plate 54 and pp. 36–9 below) is among other examples, and it is particularly interesting to note that it too has evidence of an Italian textual connection in the form of a colophon (folio 222b) copied from the exemplar, which records that the text was corrected in 558 from a manuscript which had belonged to Saint Jerome himself. The Durham Gospels (Durham Cathedral Library, MS A.II.17; plate 13 and p. 36 below), which is now attributed to the same scribe as the Echternach Gospels, although in it he is writing a different form of script, much closer to the insular majuscule practised by Eadfrith, is written in single columns.

Mention should be made of a third script characteristic of Anglo-Saxon England. This is insular minuscule, roughly speaking a cursive and time-saving form of the majuscule and, like it, developed in Ireland. This script is not used for any part of the original text of the Lindisfarne Gospels, but a later version was adopted by Aldred for the writing of his gloss. Minuscule was often used for business and legal documents and for transcribing less formal books, especially those written in the Anglo-Saxon language. Three special letter forms no longer in use in modern English are included in its alphabet for the vernacular language. These represent a 'w' and two 'th' sounds, and the two latter are still current in present-day Icelandic. One of the two persisted for several centuries in English and, because it looks very much like the modern 'y', has given rise to the spurious article 'ye' (for 'the'), very popular in 'olde worlde' contexts.

The earliest known copy of Bede's Latin *Ecclesiastical History* (University Library, Cambridge, MS Kk.5.16; plate 11) is written in minuscule. This manuscript, which is attributed to the Wearmouth–Jarrow scriptorium, was probably begun before Bede's death in 735. It is an unpretentious library copy, laid out so that no part of the vellum, which is not of the very best quality, should be wasted. Its pages contrast sharply with the spacious elegance of Eadfrith's pages. A later and more calligraphic example of minuscule, written in the second half of the eighth century and also probably from Wearmouth–Jarrow, is a copy of Bede's Commentary on the Book of Proverbs (Bodleian Library, Oxford, Bodley MS 819; plate 12), already mentioned because it contains glosses added by Aldred. This is the earliest surviving copy of the Commentary, though it must have been well-known and widely circulated in the eighth century. Saint

OVERLEAF:
10. The Greenwell Leaf. A single leaf from one of the three great Bibles written in the scriptorium of Wearmouth–Jarrow in the time of Abbot Ceolfrith. This is a particularly magnificent example of English uncial. The text is part of the Third Book of Kings. British Library, Additional MS 37777, verso.

AUDITA MORTE EIUS REUERSUS EST
DE AEGYPTO
MISERUNTQ ET UOCAUERUNT EUM
UENIT ERGO HIEROBOAM ET OMNIS
MULTITUDO ISRAHEL
ET LOCUTI SUNT AD ROBOAM DICENTES
PATER TUUS DURISSIMUM IUGUM
INPOSUIT NOBIS
TU ITAQ NUNC INMINUE PAULULU
DE IMPERIO PATRIS TUI DURISSIMO
ET DE IUGO GRAUISSIMO QUOD IN
POSUIT NOBIS ET SERUIEMUS TIBI
QUI AIT EIS
ITE USQ AD TERTIUM DIEM
ET REUERTIMINI AD ME
CUMQ ABISSET POPULUS INIIT
CONSILIUM REX ROBOAM
CUM SENIBUS
QUI ADSISTEBANT CORAM SALOMONE
PATRE EIUS DUM ADHUC UIUERET
ET AIT QUOD MIHI DATIS CONSILIUM
UT RESPONDEAM POPULO
QUI DIXERUNT EI
SI HODIE OBOEDIERIS POPULO HUIC
ET SERUIERIS
ET PETITIONI EORUM CESSERIS
LOCUTUSQ PUERIS AD EOS UERBA LENIA
ERUNT TIBI SERUI CUNCTIS DIEBUS
QUI DERELIQUIT CONSILIUM SENUM
QUOD DEDERANT EI
ET ADHIBUIT ADULESCENTES QUI
NUTRITI FUERANT CUM EO
ET ADSISTEBANT ILLI
DIXITQ AD EOS QUOD MIHI DATIS
CONSILIUM UT RESPONDEAM
POPULO HUIC
QUI DIXERUNT MIHI LEUIUS FAC
IUGUM QUOD INPOSUIT PATER
TUUS SUPER NOS
ET DIXERUNT EI IUUENES QUI
NUTRITI FUERANT CUM EO
SIC LOQUERIS POPULO HUIC QUI
LOCUTI SUNT AD TE DICENTES
PATER TUUS ADGRAUAUIT IUGUM

NOSTRUM TU RELEUA NOS
SIC LOQUERIS AD EOS
MINIMUS DIGITUS MEUS GROSSIOR
EST DORSO PATRIS MEI
ET NUNC PATER MEUS POSUIT
SUPER UOS IUGUM GRAUE
EGO AUTEM ADDAM SUPER IUGUM
UESTRUM
PATER MEUS CECIDIT UOS FLAGELLIS
EGO AUTEM CAEDAM UOS
SCORPIONIBUS
UENIT ERGO HIEROBOAM ET OMNIS
POPULUS AD ROBOAM DIE TERTIA
SICUT LOCUTUS FUERAT REX DICENS
REUERTIMINI AD ME DIE TERTIA
RESPONDITQ REX POPULO DURA
DERELICTO CONSILIO SENIORUM
QUOD EI DEDERANT
ET LOCUTUS EST EIS SECUNDUM
CONSILIUM IUUENUM DICENS
PATER MEUS ADGRAUAUIT
IUGUM UESTRUM
EGO AUTEM ADDAM IUGO UESTRO
PATER MEUS CECIDIT UOS FLAGELLIS
ET EGO CAEDAM SCORPIONIBUS
ET NON ADQUIEUIT REX POPULO
QUONIAM AUERSATUS EUM
FUERAT DNS
UT SUSCITARET UERBUM SUUM
QUOD LOCUTUS FUERAT IN MANU
AHIAE SILONITAE AD HIEROBOAM
FILIUM NABAT
UIDENS ITAQ POPULUS QUOD NOLU
ISSET EOS AUDIRE REX
RESPONDIT EI DICENS
QUAE NOBIS PARS IN DAUID
UEL QUAE HEREDITAS IN FILIO ISAI
IN TABERNACULA TUA ISRAHEL
NUNC UIDE DOMUM TUAM DAUID
ET ABIIT ISRAHEL IN TABERNACULIS
SUPER FILIOS AUTEM ISRAHEL
QUICUMQ HABITABANT IN CIUI
TATIBUS IUDA REGNAUIT ROBOA
MISIT IGITUR REX ROBOAM

11. The Moore Bede. The upper part of a page from the oldest surviving copy of Bede's most famous work, *The Ecclesiastical History of the English People*. The manuscript, which is written in insular minuscule, was apparently made at Wearmouth–Jarrow between 734 and 737. As Bede himself lived until 735, it may thus have been begun within his lifetime. University Library, Cambridge, MS Kk.5 16, folio 97b (*by permission of the Syndics of Cambridge University Library*).

BELOW:
12. Bede's Commentary on the Book of Proverbs. Part of a page from a copy made in the second half of the eighth century and attributed to Wearmouth–Jarrow. Uncial is used for headings and insular minuscule for the body of the text. Aldred, glossator of the Lindisfarne Gospels, has added one or two words between the lines. Bodley MS 819, folio 29 (*Bodleian Library, Oxford*).

Boniface, the English apostle of Germany, wrote to ask Archbishop Egbert of York to procure him a copy of it, some time between 747 and 751.

Although he wrote out the whole body of the Gospel text himself, and designed and executed the great decorated pages, it seems that Eadfrith entrusted the writing of the rubrics (or titles) to another, somewhat less talented member of the Lindisfarne scriptorium. This man also helped to make final corrections to the text, some of which amount to several lines of writing in the upper or lower margin of a page. One or two smaller corrections were added by a third hand, also contemporary, and these are of particular interest because the same hand has now been identified making corrections to the Durham Gospels, which adds to the accumulation of evidence linking this fine, but badly worn and damaged, manuscript with the monastery on Holy Island.

13. The Durham Gospels. Part of a page from a manuscript written by a contemporary of Eadfrith, who was probably also a member of the Lindisfarne scriptorium. The script is insular majuscule. Durham Cathedral MS A.II.17, folio 39 (*Durham Cathedral Library*).

5. HOW THE MANUSCRIPT WAS MADE

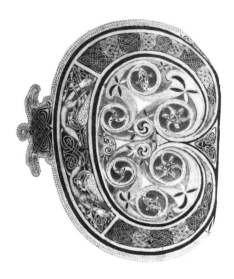

For our knowledge of the techniques and equipment involved in making early manuscripts such as the Lindisfarne Gospels, we are dependent upon three main types of evidence. First and most important is what can be gathered from close scrutiny of the manuscripts themselves. Second is evidence from archaeological sites such as Whitby and Jarrow, where writing implements have been found (plate 18). Third is evidence from written sources, some historical and some literary. Particularly revealing in this last group are some of the Latin and Anglo-Saxon riddles describing everyday objects, one of which, from the tenth-century collection known as the Exeter Book (now in the library of Exeter Cathedral), actually describes the making of a Gospel book, from the preparation of the vellum to the application of golden ornaments to its binding:

> An enemy ended my life, deprived me of my physical strength: then he dipped me in water and drew me out again, and put me in the sun, where I soon shed all my hair. After that, the knife's sharp edge bit into me and all my blemishes were scraped away; fingers folded me and the bird's feather often moved over my brown surface, sprinkling meaningful marks; it swallowed more wood-dye and again travelled over me leaving black tracks. Then a man bound me, he stretched skin over me and adorned me with gold; thus I am enriched by the wondrous work of smiths, wound about with shining metal.

Such riddles were very popular, and surviving collections include relevant examples by such contemporaries of Eadfrith as Aldhelm, abbot of Malmesbury and bishop of Sherborne (*c.* 640-709), Tatwine, archbishop of Canterbury (d. 734) and 'Eusebius', who was probably Hwaetberht, abbot of Wearmouth and a friend of Bede (*c.* 680-747).

Books written in northern Europe during almost the whole of the Middle Ages were made of vellum. This was prepared from the skins of sheep or of calves and was therefore a costly commodity. It is not at all easy to distinguish between the two types of skin, but one or two stiff brown hairs have been found still clinging to pages of the Lindisfarne Gospels, which suggests that its vellum is made from calfskin.

In the Lindisfarne Gospels the pages are arranged for the most part in gatherings of eight, which is to say that four large sheets of vellum, each large enough for two pages, were placed one above the other and folded in two down the middle to make eight leaves. The manuscript contains 258 leaves, for which at least 129 large pieces of vellum, each measuring rather more than two feet by fifteen inches, were required. Close examination of the pages shows that the spines of the animals run horizontally across the book. We do not know the age or size of the calves involved, but it may well be that each large sheet represents one animal, which means that the number and value of the animals

involved was very substantial. Both flesh and hair sides have been most expertly prepared to form a good and stable writing surface, very white in colour, and it is extremely hard to distinguish one from the other.

Once the sheets had been folded together to make a group of pages, the uppermost page was carefully measured out and the framework of the writing area marked by pricking. This was done sometimes with a sharp round stylus and sometimes with the point of a small knife, the latter leaving a tiny wedge-shaped rather than a round hole. These holes were pricked right through the entire gathering of eight leaves, then each individual text leaf was separately ruled for writing with a hard, dry point, very lightly so as to be as unobtrusive as possible. Each of the two text columns on a page is bounded by a double vertical line on the left and a single one on the right. The small initials at the beginnings of verses are governed by the left-hand rulings (plate 14). The horizontal lines on which the text is written are ruled between guiding prick marks lying on the extreme right-hand and extreme left-hand vertical lines. A pair of parallel rulings is provided for each of the 24 or 25 written lines in each column and, as each pair is of exactly the same width in spite of the fact that only the lower of the two lines is guided by a prick mark, we must assume that Eadfrith had a double-pointed instrument with which to make them.

The text of the Gospels is written in a dense, dark brown ink, often almost black, which contains particles of carbon from soot or lamp black. The pens used by Eadfrith may have been cut either from quills or from reeds. No direct evidence for either can be expected to emerge from archaeological investigation, as neither would be likely to survive in the soil. More than one of the riddles, including the one quoted above, apparently refers to the quill pen, but both reeds and quills are likely to have been readily available on or near Holy Island in Eadfrith's day. Today Holy Island is a celebrated bird sanctuary, its seasonal visitors including several sorts of goose, whose feathers are particularly well-suited for use as pens. It will be remembered that one of Saint Cuthbert's own miracles involved the cooking of a goose, implying their presence locally. Suitable reeds are also to be found in the area today, and could certainly have been obtained on the mainland if not on the island itself in Eadfrith's day.

When preparing his pages for writing, Eadfrith took immense pains not to allow his rulings to mar the smooth surface on leaves intended for pure decoration. Three of the five cross-carpet pages, those preceding Matthew, Luke and John, are not part of the basic gathering in which they appear but have been inserted separately. The Mark carpet is painted on the final verso of an irregular gathering devoted only to the prefatory material for that Gospel. The astonishingly complex designs on these pages are painstakingly built up over a measured geometric framework, traces of the construction work for which can be seen on the blank rectos of the leaves in the form of prick marks, compass holes, rulings and grid lines (plates 14-17). It appears that, within this mathematical framework, the more subtle curves were then drawn purely by eye. It has been suggested that templates were used in the execution of some seventh- and eighth-century manuscripts, and there certainly seems to be evidence that templates were part of a pre-Conquest stone-carver's equipment. In the decoration of the Lindisfarne Gospels there is nothing which immediately suggests the use of such an aid. Some of the outlines for the decoration were drawn with a dry point, and it is occasionally possible to see, under oblique light, places where the illuminator changed his mind. For

OPPOSITE ABOVE:
14. Enlarged detail showing the prickings and rulings which govern the arrangement of the script and minor initials. The Lindisfarne Gospels, folio 152b.

OPPOSITE BELOW:
15. Enlarged detail showing prickings and rulings on the reverse side of the central roundel of the cross-carpet page preceding Saint Mark's Gospel. The Lindisfarne Gospels, folio 94.

epeccatorib

caus abibtus

Gresponders

dixit achillos

non egent quisq

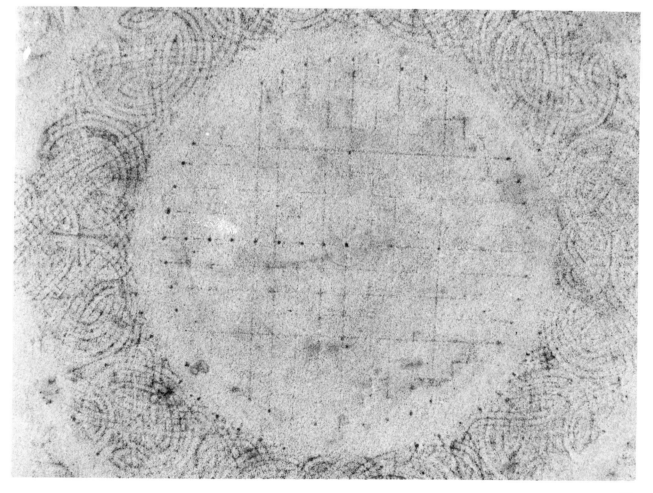

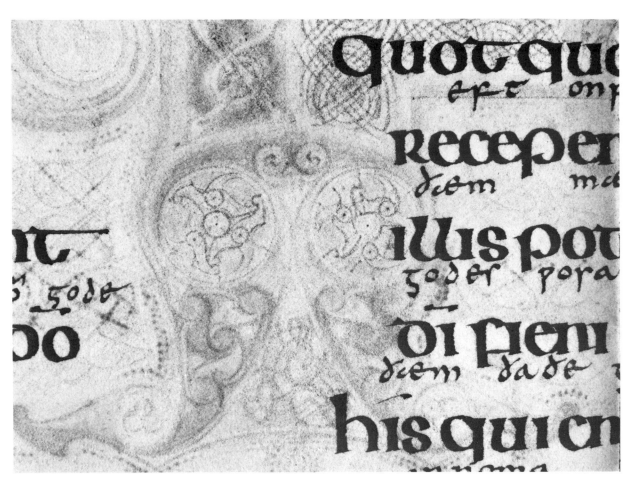

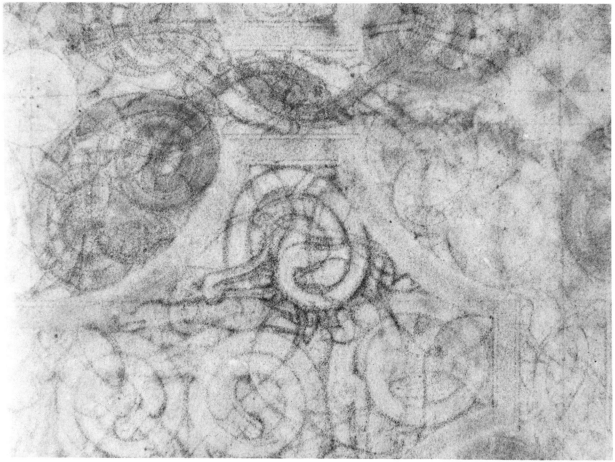

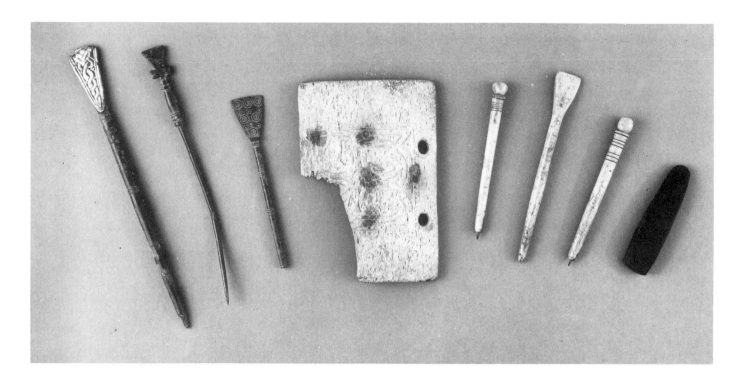

18. Anglo-Saxon writing implements. The largest stylus is about 5½ inches long. The carved bone tablet in the middle of the picture is hollowed on the other side to receive a wax writing surface. The styli to its left are made of bronze, those to its right of bone. The object on the extreme right is a miniature whetstone, used for sharpening a small knife. With the exception of the tablet, which was found at Blythburgh, all these objects were discovered during excavations at Whitby in the 1920s (*British Museum, Department of Medieval and Later Antiquities*).

OPPOSITE ABOVE:
16. Enlarged detail showing some of the construction marks on the reverse side of the major initial at the beginning of Saint John's Gospel. The Lindisfarne Gospels, folio 211b.

OPPOSITE BELOW:
17. Enlarged detail of a section of the 'pencil' sketch marks on the reverse side of the cross-carpet page preceding Saint Matthew's Gospel. The Lindisfarne Gospels, folio 26.

example, the decorative corner pieces on the frame around the miniature of Saint Matthew (plate 23) were originally to be much larger and heavier than in the final version. There are also traces of the use of a substance approximating to modern pencil, especially on the reverse sides of the decorated and major initial pages (plate 17).

It seems necessary to assume that some sketches preceded the execution of the finished pages, an equivalent to the carved bone 'trial pieces' associated with metalwork and found on pre-Conquest sites. These sketches, like the pens, have vanished without trace, and indeed there is a conspicuous lack of all such material for the whole of the Middle Ages. Costly sheets of vellum would not have been used in quantity for such a purpose. Rough preliminary designs could perhaps have been made on wax tablets, which were a common personal accessory during the period under discussion. Only one specimen has as yet been found in England (plate 18), but there is considerable written evidence for their existence. They were among the items of everyday equipment which the fifth-century Rule of Saint Benedict lists as essential for a monk. Wax tablets were made of wood or bone, with one or both surfaces hollowed out to receive a shallow layer of wax, on which it was possible to write or draw with the point of a stylus (plate 18). When the notes or sketches had served their purpose, the wax surface, perhaps slightly warmed, could be smoothed out with a spatula, usually provided at the other end of the writing implement. Two or more tablets might be joined together with thongs to form a little notebook. One of Aldhelm's riddles describes a wax tablet:

Of honey-laden bees I first was born, but in the forest grew my outer coat; my tough backs came from shoes [the leather thongs]. An iron point in artful windings cuts a fair design, and leaves long twisted furrows, like a plough.

A specific and relevant use of wax tablets in the planning of a book is recorded by Adamnan, abbot of Iona 679-704. Adamnan wrote an account of the Holy Places in Palestine, based on the pilgrimage experiences of a Frankish bishop called Arculf, who was blown off course to Iona on his return home. Adamnan tells us in his preface that

he wrote down Arculf's story on tablets, as he told it, and then persuaded his guest to make sketch plans on the wax of the places he had seen, especially the Church of the Holy Sepulchre. From these sketches, the diagrams for the finished book were prepared.

A large and subtle range of colours is used in the decoration of the Lindisfarne Gospels, and these have been examined in some detail. It is not, of course, feasible to remove specimens from a medieval master-piece for scientific analysis, so microscopic examination under various types of light was employed. Pigments prepared in accordance with various later medieval recipes were painted onto vellum for compari-sons to be made. Results suggested that the binding medium used for most of Eadfrith's colours was simple white of egg, though in one or two cases it might have been fish glue. Recognized sources of indi-vidual colours include red and white lead, verdigris, yellow ochre, yellow arsenic sulphide (orpiment), kermes (a red colouring obtained from insects living on evergreen oak trees in lands bordering the Mediterranean), gall, and indigo (from an oriental plant) or woad (from a plant cultivated in northern Europe). A fine range of pinks and purples comes from folium, prepared from the fruit and flowers of the turnsole plant and treated with varying amounts of alkalines. Perhaps the most exotic source of colour is blue lapis lazuli, the only contemporary source of which was Badakshan, in the foothills of the Himalayas, far beyond Eadfrith's personal knowledge and ex-perience. It must have passed through many hands before reaching the monastery in Northumbria. Gold, in paint form and not in the raised, burnished form familiar in later manuscripts, is used only for one or two tiny patches on the major initial pages to Matthew and Luke (plates 25 and 32) and for the 'title' at the head of each Gospel. It was in general not a feature of early insular manuscripts, though both gold and silver are used quite extensively in the Codex Amiatinus, to emulate an earlier book from Italy. This was no doubt a matter of insular taste rather than a lack of raw materials, as gold was used lavishly in jewellery and was, as we have seen, added to the binding of the Lindisfarne Gospels later in the eighth century. All Eadfrith's colours are applied with great skill and accuracy but, as with the script, we have no means of knowing exactly what implements he used.

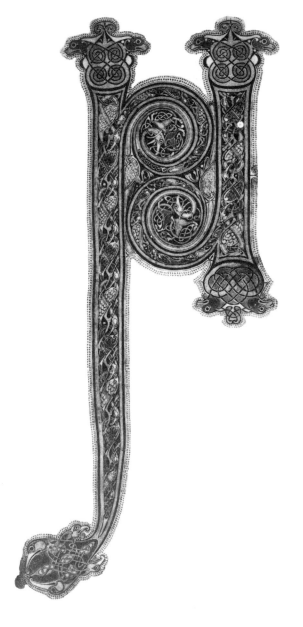

6. THE GREAT DECORATED PAGES

There are 15 elaborate fully decorated pages in the Lindisfarne Gospels. Each of the four Gospels is preceded by an illustration depicting its author with his symbol, and is introduced by a cross-carpet page and a major initial page. A second major initial page occurs in Matthew (1:18), to mark the beginning of the story of the Incarnation. There is a further cross-carpet page and a major initial page at the very beginning of the manuscript, introducing Saint Jerome's letter to Pope Damasus. There are also 16 pages of decorated Eusebian canon tables, enclosed within decorated arcades. The 15 main decorated pages, together with two examples from the sequence of canon tables, are all reproduced within this chapter, following the exact order and arrangement in which they appear in the manuscript.

A manuscript such as the Lindisfarne Gospels, richly decorated both inside and out and obviously intended for ceremonial use, played a symbolic as well as practical role in the life of the Church during the early centuries of conversion. It visibly represented the Word of God which the missionaries had carried to their converts. The early clergy were by no means unaware of the profound impression which a splendid book could make upon their often very primitive congregations. In 735 or 736 Saint Boniface asked his friend Abbess Eadburga of Minster-in-Thanet to make for him a copy of the Epistle of Saint Peter in letters of gold, so that its appearance would help to secure honour and reverence for Holy Scripture every time he used it. Every new church must have needed some form of Gospel book to supply a text for liturgical readings, and the provision of a new and more splendid Gospels is among the activities attributed to the benefactors of the ideal church described in the *De Abbatibus* of Ethelwulf. Such a gift is described by Eddius Stephanus, the biographer of Saint Wilfrid of York, probably writing shortly after his subject's death in 709. In the 670s Wilfrid built and equipped the church at Ripon, where he had taken over the monastery originally established by Saint Cuthbert and his companions from Melrose. To the church he gave 'a marvel of great beauty hitherto unheard of in our times. For he had ordered, for the good of his soul, the four Gospels to be written out in letters of purest gold on purpled parchment and illuminated. He also ordered jewellers to construct for the book a case made all of purest gold and set with most precious gems.' This manuscript, alas, has not come down to us. From the description it sounds as though Wilfrid may have procured it on his continental travels rather than from an English scriptorium. Books written in gold and silver on purpled parchment were well known to Saint Jerome in the fourth century, who regarded their opulent splendour with distaste and dubbed them 'burdens, not books'.

The Lindisfarne Gospels is not the only insular Gospel book to have survived from the seventh and eighth centuries, but it is the best-

OVERLEAF:
19. Cross-carpet page introducing Saint Jerome's letter to Pope Damasus. The Lindisfarne Gospels, folio 2b.

20. Major decorated initial page at the beginning of Saint Jerome's letter to Pope Damasus. The Lindisfarne Gospels, folio 3.

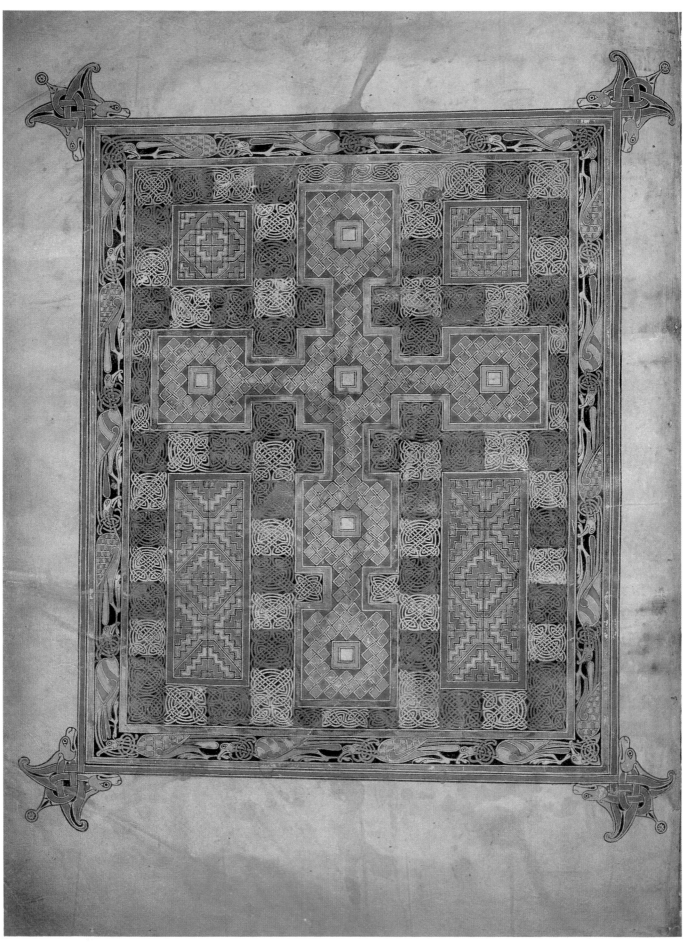

34

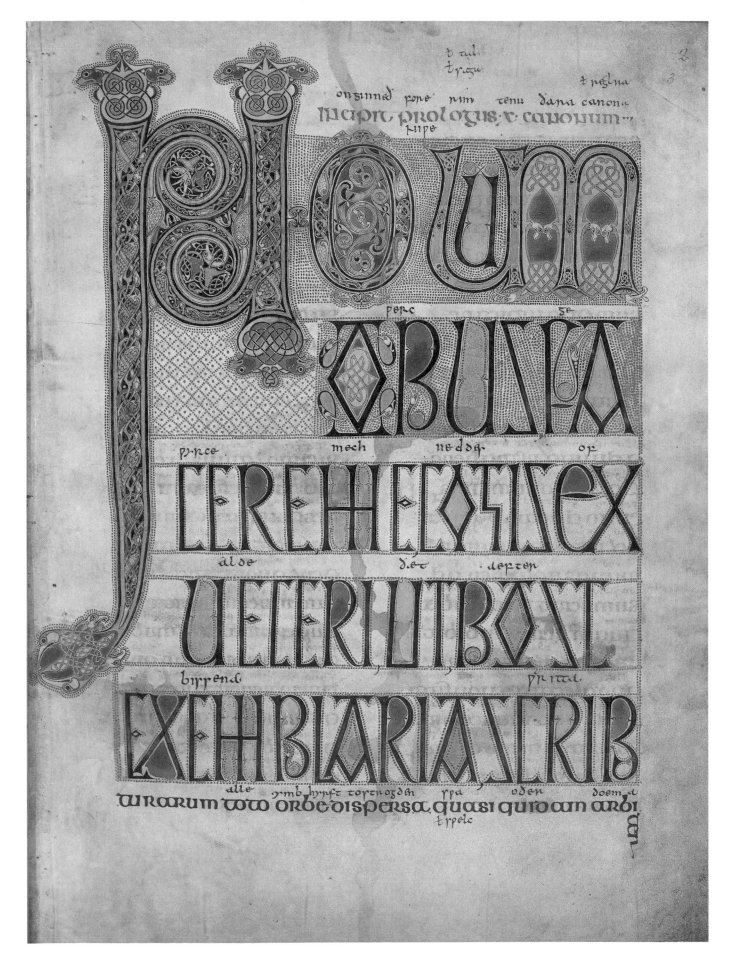

documented and also the most complete, having apparently lost neither text nor decoration during the thirteen centuries of its existence. Four or five other manuscripts of similar date may be compared with it. All contain major illuminated pages and must in their time have been extremely splendid, though all have suffered from time and use, some much more than others.

The earliest of these comparable books is the Book of Durrow (Trinity College, Dublin, MS A.4.5(57); plate 53), which was written and illuminated probably about 675, some 20 years earlier than the Lindisfarne Gospels. It takes its name from the Irish monastery of Durrow, in County Meath, where it certainly was in the late eleventh or early twelfth century. It was somewhere in Ireland even earlier than this, because we know that a 'cumdach' (a shrine-like book casket), now lost but known in the seventeenth century, was provided for it by King Flann, who died in 916. There has been much disagreement over the original provenance of this manuscript. Some scholars insist that it was unquestionably made in Ireland, others argue for Northumbria as a more likely place of origin. A request for prayers for Columba the scribe (folio 247b) is often taken as a reference to Saint Columba of Iona (d. 597), who numbered Durrow itself among his many monastic foundations in Ireland. Columba was noted for his prowess as a scribe, personally copying out books needed by the many churches in his care, and it is possible that the scribe of the Book of Durrow used one of these as an exemplar. It is also possible either that the seventh-century scribe's own name was Columba or that his inscription was merely a pious addition. If, however, a reference to Saint Columba is intended, the monastery of Iona is itself a third possible place of origin for the manuscript.

The Book of Durrow contains six decorative carpet pages, five major initial pages and five pages depicting the symbols of the four Evangelists, the man, the lion, the calf and the eagle. The four symbols appear together on one page at the beginning of the book. There is a carpet page at the end of the volume as well as at the beginning, and it seems that a seventh carpet, which should precede Matthew, is lacking. The Eusebian canon tables are written out on five pages, distinguished by simple rectangular frames containing plaitwork. The general arrangement of the manuscript's decoration is very similar to that of the Lindisfarne Gospels, but its design is far less complex and the range of colours employed by the illuminator is very limited. The manuscript shows signs of hard wear over a long period of time.

Apparently more nearly contemporary with the Lindisfarne Gospels is an incomplete and badly damaged Gospels in the library of Durham Cathedral (MS A.II.17; plate 45). This must once have been a book of great magnificence. The surviving decoration comprises a major initial page to Saint John's Gospel and a miniature of the Crucifixion, placed at the end of Matthew. The structure of the gatherings suggests that there were once either carpet pages or Evangelist/Evangelist symbol miniatures, as well as major initial pages, at the beginning of each Gospel, and that there may also have been a miniature at the end of each. There are strong reasons for connecting this manuscript with the Lindisfarne scriptorium because, as we have already seen, the hand of the author of minor corrections in the Lindisfarne Gospels itself has recently been recognized in it. In addition to this, it is known to have been with the other Lindisfarne treasures at Chester-le-Street in the tenth century.

To the scribe of the Durham Gospels is now attributed the famous Echternach Gospels (Bibliothèque Nationale, Paris, MS lat. 9389;

21. The third in Eadfrith's sixteen-page sequence of arcaded canon tables. In this example interlaced birds fill the columns and the arch, while a fairly simple ribbon knotwork design is used for the bases and capitals. The Lindisfarne Gospels, folio 11.

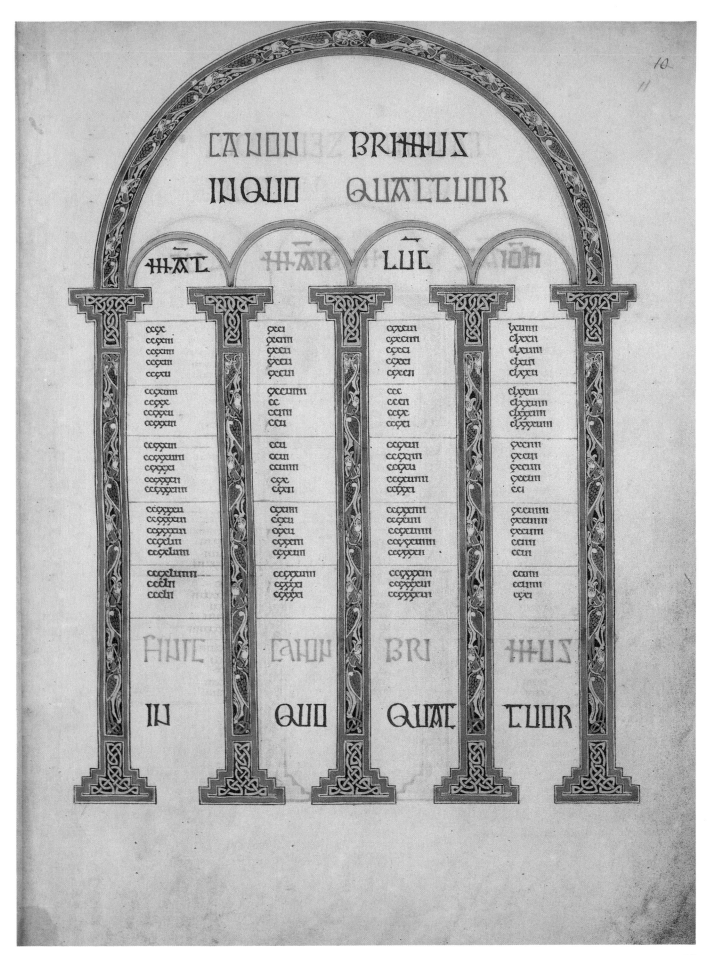

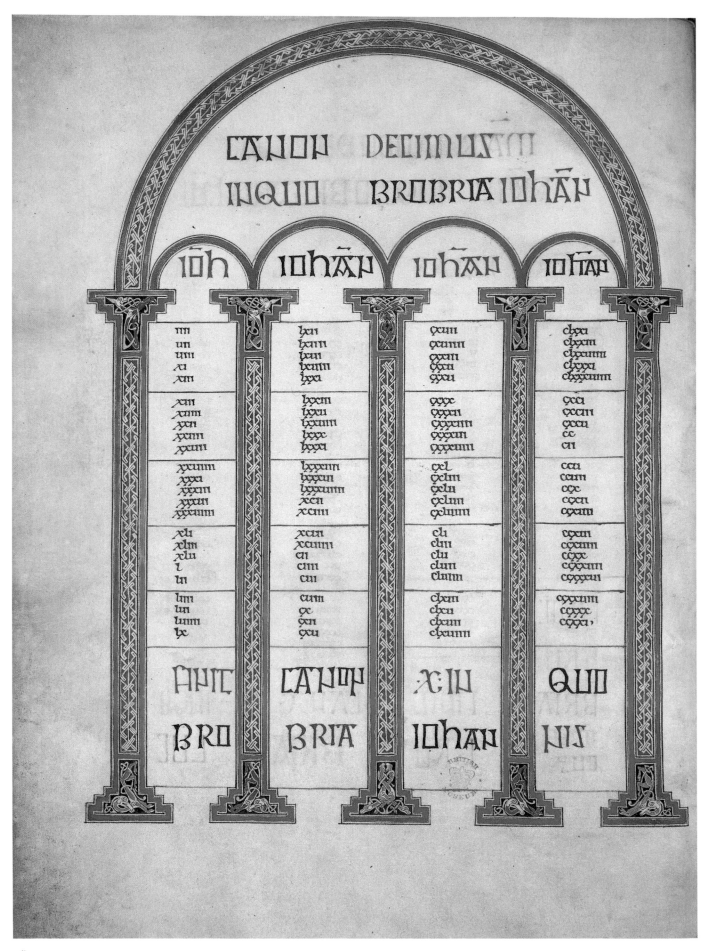

plate 54). This is ornamented with full-page pictures of the symbols of the four Evangelists, decorative initials on a fairly modest scale at the beginning of each Gospel, and canon tables within simple, coloured rectangular frames. There are no elaborate carpet pages, but in other ways the decoration of this manuscript suggests a distinct family relationship to the Book of Durrow. It has in the past been variously attributed to Ireland and also to the monastery of Echternach, where it certainly was in the fifteenth century. However, historical as well as palaeographical evidence can be used to support an attribution to Lindisfarne. The community at Echternach was established in or about 698, the year of Saint Cuthbert's elevation, by Saint Willibrord, the apostle of the Frisians. Willibrord was born in Northumbria and had gone as a missionary to Frisia in 690. His efforts met with much success and, probably in 695, he went to Rome to be consecrated archbishop for the new see of Utrecht, which was set up in the following year. By May 706 monastery buildings had been erected at Echternach, and the community was under the protection of Pepin, King of the Franks, the saint's special patron. It was Willibrord's own favourite foundation, and he was buried there when he died in 739. The town of Echternach still celebrates his festival with a dancing pilgrimage through the streets to his tomb in the basilica.

It is clear from the Life of Saint Willibrord, written by Alcuin of York, that he maintained close contact with Northumbria throughout his career. A member of his household was actually at Lindisfarne shortly after the elevation of Saint Cuthbert's relics, and was miraculously cured of a sudden illness by a painful visit to the saint's new resting place. A fine copy of the Gospels would have been considered a most fitting fraternal gift, either for Willibrord's new monastery or for his new cathedral. The very fluid, almost cursive, appearance of the script in the Echternach Gospels, and the simple but arresting design of its decorated pages lend support to the idea that the manuscript was produced in a short space of time for some particular reason, perhaps to be ready for presentation to mark a significant date such as a dedication ceremony, or perhaps to meet a deadline imposed by the availability of a suitable courier. Whatever the circumstances, the events of Willibrord's life suggest that a date very close to the date of the Lindisfarne Gospels is likely.

Parallels for the Echternach Evangelist symbol pages are found in a now fragmentary and divided Northumbrian Gospel book of which there are 36 leaves in the library of Corpus Christi College, Cambridge (MS 197 B, folios 1-36) and a collection of fire-distorted fragments in the British Library (Cotton MS Otho C.v). The Cotton fragments were unfortunately damaged beyond repair in the Ashburnham House fire of 1731, from which the Lindisfarne Gospels was mercifully saved. However, the figure of a leaping lion, very like the one in the Echternach Gospels, can still be distinguished among them, as can an introductory initial page for Saint Mark's Gospel. The leaves in Cambridge include an illustration of Saint John's eagle and an accompanying initial page. There is no trace of decorative carpet pages. However, it is possible that a set of arcaded canon table pages, now represented only by some shadowy offsets in British Library, Royal MS 7 C.xii (folios 2, 3), was once part of this manuscript. These are the only known arcaded canon tables of so early a date with distinctly insular decoration, apart from the ones in the Lindisfarne Gospels.

The Gospels of Saint Chad, in the library of Lichfield Cathedral, displays the most striking resemblances of all to the Lindisfarne Gospels. This manuscript, which must originally have been of quite

22. The last of the canon table pages. Here animal motifs are ingeniously induced to fit bases and capitals, the columns and arch being decorated with a diagonal fret pattern. The Lindisfarne Gospels, folio 17b.

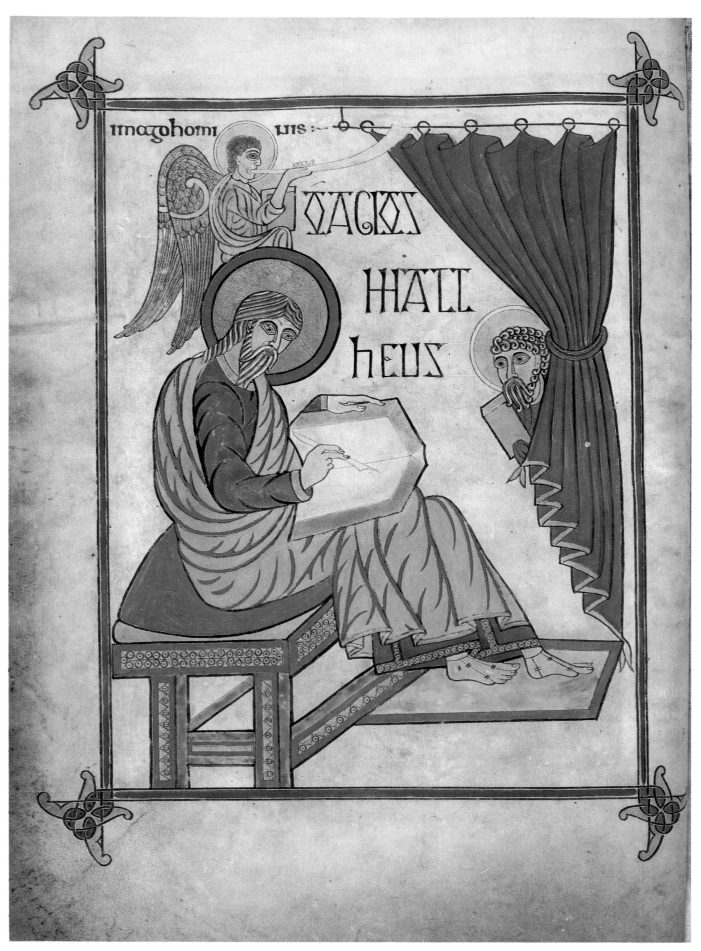

imago homi nis : ᚱᚩᚷᚫᚳᚳᛖᛋ ᛗᚪᛏ ᚻᛖᚢᛋ

outstanding beauty, is now very much damaged and worn. There are no clues to its place of origin, but it probably dates from the early eighth century. A number of documents copied onto its pages about the beginning of the ninth century reveal that it was by then in Wales, where it was offered on the altar of Saint Teilo (at Llandeilo-fawr, in South Wales) by Gelhi, son of Arihtuid, who had exchanged his best horse for it. It was quite common for legal documents, often concerned with grants of property to a monastery or church, to be copied for safe-keeping into a Gospel book, sacrosanct because of its associations. The Saint Chad Gospels apparently reached Lichfield some time in the tenth century and has ever since been associated with the name of Lichfield's patron, Saint Chad (who, interestingly enough, was educated at Lindisfarne), though he died in 672, far too early to have any connection with the manuscript. The sequence of decorated pages at the beginning of Saint Luke's Gospel is still complete and consists of a miniature of the Evangelist, a page with the four Evangelist symbols, a cross-carpet page and a major initial page (plate 42). There are three further major initial pages still in the book, two in Matthew and one in Mark, and a miniature of Saint Mark (plate 60). Most of the text of Luke and the whole of John are missing. It is likely that each Gospel was originally preceded by a series of decorated pages equivalent to those which remain before Luke, and there may also have been decorated canon table pages. The surviving carpet page and the initial pages are very closely related in design to similar pages in the Lindisfarne Gospels, so closely indeed that it seems necessary to assume that their artist had seen Eadfrith's work.

Mention must also be made of the Book of Kells (Trinity College, Dublin, MS A.1.6(58)), the decorative scheme of which has much in common with that of various of the insular Gospel books with which we have been dealing. It seems, however, to be considerably later in date than the Lindisfarne Gospels, and the questions of style and origin which it inspires are so very complicated that little is to be gained by introducing it into the present discussion.

The principal decorated pages of the Lindisfarne Gospels relate in some degree to decorated pages in each of the manuscripts just described, but they also display some marked differences. In particular the canon table pages, and the miniatures of the four Evangelists with their symbols, are treated very differently from those in other books.

Canon tables were devised early in the fourth century by Eusebius, bishop of Caesarea, to provide a system whereby parallel passages in the four Gospels could readily be located. Their long and visually unattractive columns of figures (corresponding to figures added in the margins beside the Gospel texts, examples of which can be seen in plates 8 and 14) offered considerable scope to the enterprising decorator, and in many early medieval copies of Gospels some of the finest illumination will be found associated with them. The total number of pages used could be varied in accordance with the degree of luxury of the manuscript. Two of the insular Gospel books described above still have their canon tables, but in neither does the decoration approach the complexity of Eadfrith's work. In the Book of Durrow the five pages of tables are given ornamented borders. In the Echternach Gospels they are simply framed in plain coloured bands. Only in the faint offsets possibly once a part of the book now divided between Cambridge and London do we see traces of arcaded canon tables with insular ornament applied to their architectural framework. There is one other contemporary series of arcaded canon tables in an insular manuscript, preceding the New Testament in the Codex

23. Full-page miniature of the Evangelist Saint Matthew, accompanied by his symbol, a winged man blowing a trumpet and carrying a book ('imago hominis'), and by a mysterious figure which may perhaps be intended to represent Christ. The Lindisfarne Gospels, folio 25b.

OVERLEAF:
24. Cross-carpet page introducing the Gospel according to Saint Matthew. The Lindisfarne Gospels, folio 26b.

25. Major decorated initial page at the beginning of the Gospel according to Saint Matthew. The Lindisfarne Gospels, folio 27.

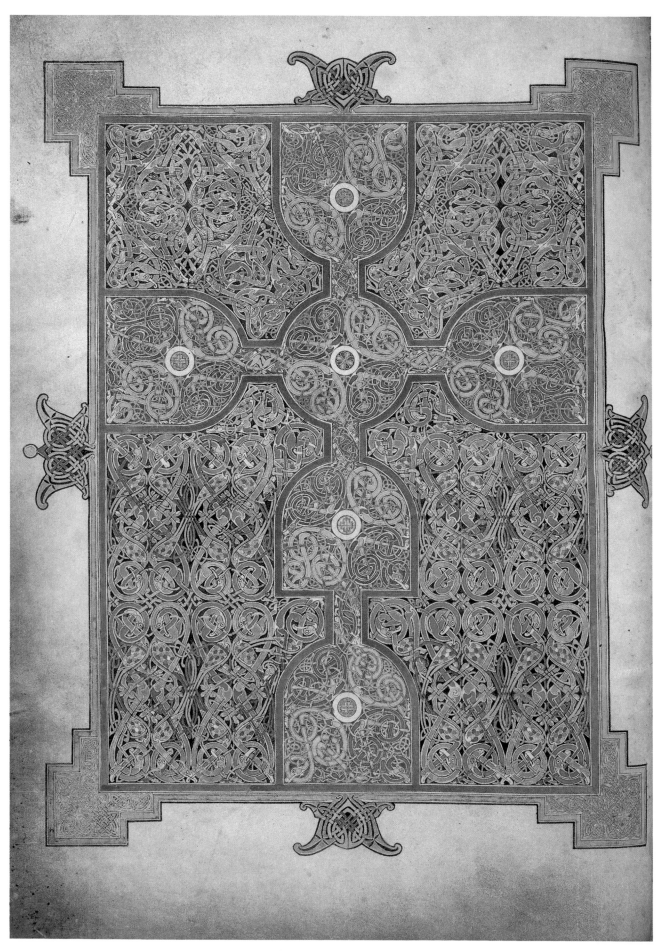

42

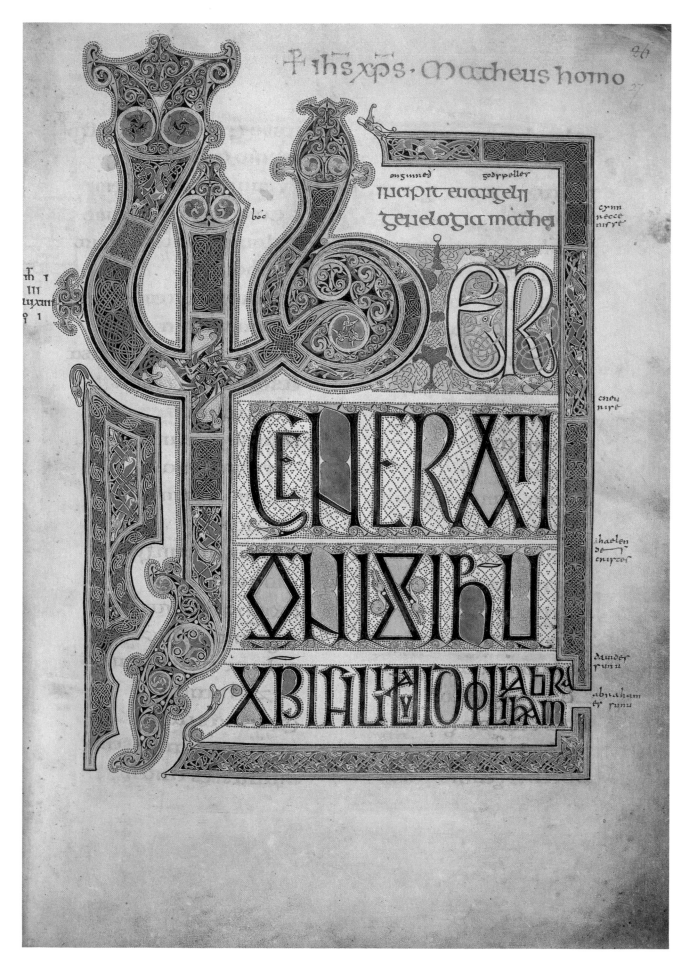

Amiatinus, but the decoration of these follows their late antique model.

Eadfrith's canon tables (plates 21 and 22) occupy a sequence of 16 pages, making up a complete gathering of eight vellum leaves. They are set within architectural arcades, the pillars and main arches of which are filled with varied and elaborate interlace designs. The first and last pages of the series are of individual design, but the remainder are in matching pairs, one pair to each opening of the book. The scheme as a whole must certainly have been inspired by knowledge of a set of arcaded canon tables in one of the manuscripts brought to England from Italy, where similar pages were certainly familiar. It would not have been beyond Eadfrith's powers of invention to adapt the Codex Amiatinus set, presumably based upon those in the Codex Grandior, although they are laid out to appear in the context of far larger pages than those which he was designing. A more likely source is the other Cassiodoran Biblical manuscript at Wearmouth–Jarrow, the Novem Codices. The seventh volume of this, containing the Gospels, would certainly have included canon tables, in a format closer to that of the Lindisfarne Gospels.

The decoration of Eadfrith's arcades is unmistakably insular, though it is possible that his decision to make such extensive use of bird motifs was inspired by the appearance of bird processions in his model, as these are quite commonly used in Mediterranean art. However, all the motifs which appear in the canon tables will be seen again in the decoration of the cross-carpet and major initial pages of the manuscript. He made no attempt to persuade his arcades to take on the appearance of marble, though this common antique device was to be enthusiastically adopted by later illuminators, as well as by the artist of the Codex Amiatinus. The arcades of the Lindisfarne Gospels are filled with long flat ribbons of entwined birds or straightforward interlace; bases and capitals enclose contorted beasts or knots cleverly moulded to fit an awkward space, and the whole relies successfully upon the alternation of animal and simple interlace ornament and upon some striking variations of colour for its lively effect.

Eadfrith's miniatures of the four Evangelists are very different from representations of the human figure in other insular Gospel books. From the clothing and accessories of the four seated figures (plates 23, 27, 30 and 33) it is at once clear that the inspiration lying behind them was, as in the case of the canon tables, the decoration of a late antique manuscript imported from the Mediterranean. Although the artist's love of pattern is in each case reflected in the addition of an overall network of folds picked out in a colour contrasting with that of the garment, his figures are still convincingly clothed in a fabric and not protected by a chequered tabard (as in Saint Matthew's man symbol in the Book of Durrow) or hung about with pneumatic loops (as in the Evangelist pictures of the Saint Chad Gospels; plate 60). All four Evangelists wear classical sandals, though these appear merely as very slender thongs, the soles having been omitted. Faces and hair are reduced, like the garments, to a very strong linear pattern but without losing their essential realism. Each Evangelist is accompanied by his symbol, those of Mark and Luke seen virtually in entirety, those of Matthew and John partially obscured by the haloes of their respective saints. The Matthew and Mark symbols are blowing trumpets, and all four have wings. Saint Matthew is also accompanied by a mysterious haloed figure with a book peeping out from behind a curtain. The arrangement is very reminiscent of that in later manuscripts of the *Registrum Gregorii* (the collected letters of Pope Gregory the Great),

26. Second major decorated initial page from the Gospel according to Saint Matthew, marking the beginning of the Christmas story. The Lindisfarne Gospels, folio 29.

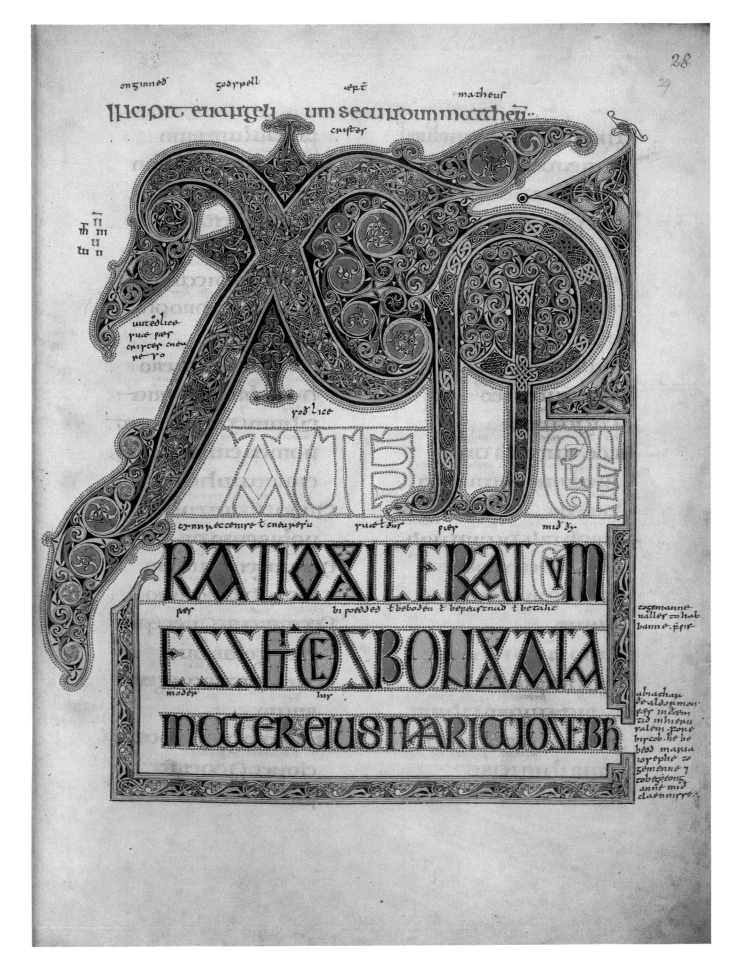

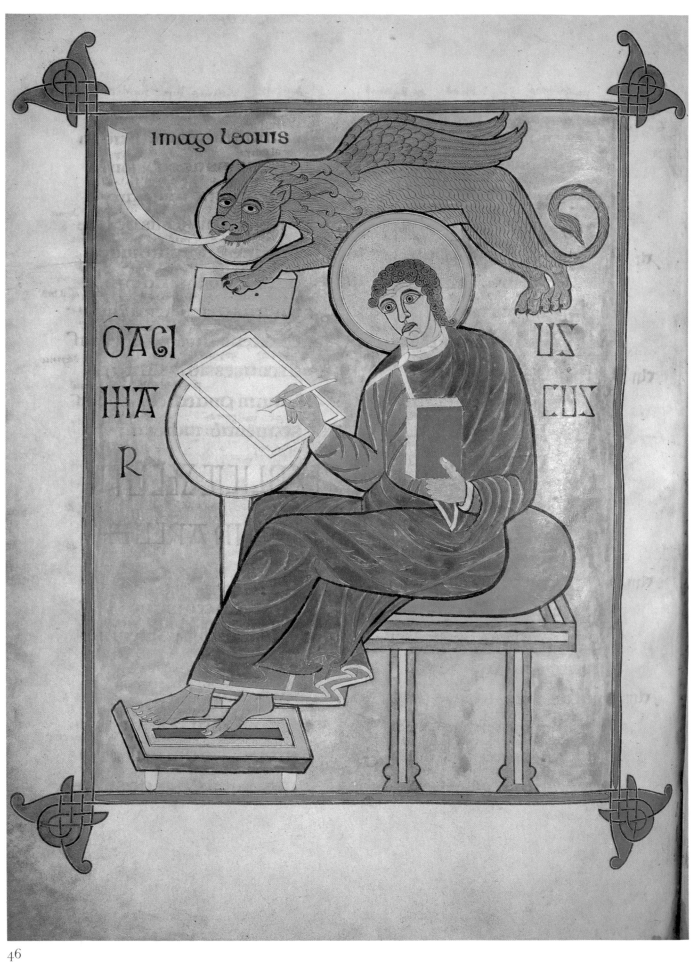

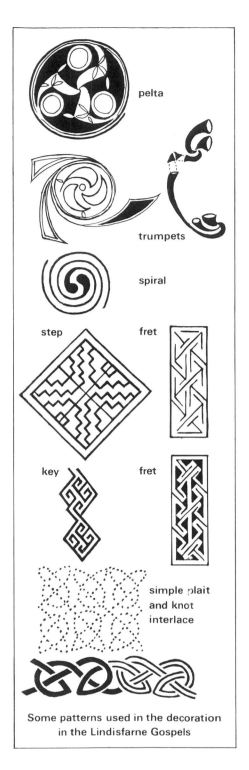

pelta

trumpets

spiral

step

fret

key

fret

simple plait
and knot
interlace

Some patterns used in the decoration
in the Lindisfarne Gospels

OPPOSITE:
27. Full-page miniature of the Evangelist Saint
Mark, accompanied by his symbol, a winged
lion blowing a trumpet and carrying a book
('imago leonis'). The Lindisfarne Gospels, folio
93b.

OVERLEAF:
28. Cross-carpet page introducing the Gospel
according to Saint Mark. The Lindisfarne
Gospels, folio 94b.
29. Major decorated initial page at the
beginning of the Gospel according to Saint
Mark. The Lindisfarne Gospels, folio 95.

where the attendant deacon manages an illicit glimpse of Pope
Gregory the Great while he is being inspired by the Holy Dove. This
figure has caused much discussion, and may possibly represent Christ.

Although Eadfrith's distinctive style has imposed upon the
Evangelist pages the appearance of a coherent series, they are ap-
parently not derived from a single set of Evangelist pictures. The close
relationship of the first miniature, that of Saint Matthew, to the
miniature of Ezra in the Codex Amiatinus (plate 59) has long been
recognized. The Ezra picture must have been taken from one of the
Cassiodoran manuscripts at Wearmouth–Jarrow, and the inclusion in
it of a cupboard containing a Bible in nine volumes, appropriately
labelled to represent the Novem Codices, strongly suggests that the
model behind it, and therefore also behind Eadfrith's Saint Matthew,
was a frontispiece to the Novem Codices themselves. The seventh
volume of the same set of manuscripts, containing the Gospels, is a
likely source for the other three Evangelists, as it was for the canon
tables, but this can never be proved one way or the other as the book
has long since disappeared. The Cassiodoran Evangelists are unlikely
to have been accompanied by their symbols and, if the model for
Matthew has been correctly identified, we know that it, of course, was
not. The symbols must therefore have been added by Eadfrith from
some other source and are closest to those seen on the exactly contem-
porary oak coffin made to receive Saint Cuthbert's relics in 698 (plate
61) and to those on the Maiestas page of the Codex Amiatinus, though
the latter, while winged, have neither trumpets nor books. The use of
two separate sources for the Evangelists and their symbols is probably
underlined by the use of Latin for the inscriptions identifying the
symbols and of the Greek 'O agios' preceding the names of the
Evangelists.

The 11 other major decorated pages of the manuscript are all
composed of pure ornament, each based either on a cross shape or on
an initial followed by a sequence of letters. The ornament of these
cross and initial pages is of amazing intricacy. Eadfrith had a highly
developed sense of form and design which enabled him to fill even the
most awkwardly shaped segments of his field with fluid arrangements
of various types of decoration. Every one of the cross-carpet and initial
pages calls for detailed examination, section by section, preferably
with the aid of a magnifying glass, to bring out the full richness of its
contents. The decoration is of several different types, woven and
interwoven into a coherent whole, representing the high-water mark
of the preoccupation with pattern which is a characteristic of early
Anglo-Saxon art in all media.

Many of the patterns used by Eadfrith and his contemporaries go
back far beyond the Christian period. Prominent are curvilinear
motifs such as those which fill the bows of the letters on the Incarnation
page (plate 26) and on the opening page of Luke (plate 32). The
spiral, the trumpet and the pelta are all familar in Celtic art of the Iron
Age. There are many varieties of plait and knot work, woven from
'flat' bands of colour or from simple lines, sometimes used in alternat-
ing areas of contrasting colour. Step, fret and key patterns are also
among the purely linear elements. Most characteristic of all is the
zoomorphic interlace, adopted from Germanic art and distinguished
in the Lindisfarne Gospels by the extensive introduction of interlaced
birds in addition to the more usual interlaced quadrupeds. The latter
often have elongated, almost serpentine bodies, and legs, ears and tails
are all stretched out to form part of the pattern. These animals tend,
for the sake of convenience, to be described as dogs, though most of

47

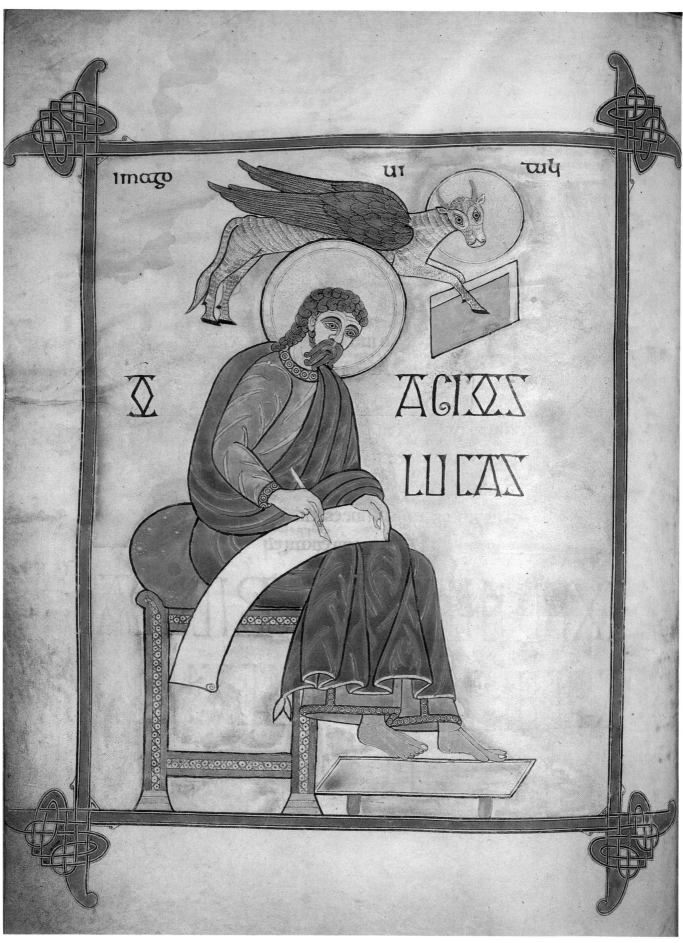

imago ui tuli

ACIES LUCAS

them are entirely fanciful. However, one seems quite certainly intended for a cat, creeping down the side of the Saint Luke initial page (plate 32) in search of further prey to add to the eight birds already entwined within her.

Eadfrith's birds have excited much scientific discussion, largely inspired by the suggestion that he had some specific local fowl in mind, since Holy Island and its surroundings are so very rich in wildlife. Informed ornithological opinion has discounted the attractive theory that the birds are meant for cormorants or for their cousins, the shags, both of which nest today in colonies on the Farne Islands. Certainly Eadfrith's birds cannot be regarded as accurate, scientific drawings, and their sinuous feet, with long, cruel talons, are not the feet of water birds. Nevertheless it is hard not to see in them some reflection of the cormorant family, seated in characteristic attitude on the rocks with necks and beaks proudly extended and with the sun striking the gleaming irridescence of their feathers.

One further very distinctive form of ornament is used to more striking effect in the Lindisfarne Gospels than in any other insular manuscript. This is the technique of applying tiny drops of red lead to the page, forming backgrounds, outlines or patterns as the space dictates. Red dots appear in the earliest Irish manuscripts, generally employed to enhance the outlines of otherwise simple initial letters. In the Lindisfarne Gospels too they are associated with letters, both on text pages and on the great initial pages, and never contribute to pages of pure ornament. On the most thickly dotted page, the initial page at the beginning of Luke (plate 32), approximately 10,600 red dots have been counted. They are very carefully applied and experiment suggests that a rate of 30 dots per minute might be achieved. Application of the dots on the Saint Luke page would thus have taken a basic minimum of six hours' hard work.

The first pair of decorated pages (plates 19 and 20), standing at the very beginning of the manuscript and introducing Saint Jerome's letter to Pope Damasus, is much the least complex of the series in the manuscript. The cross formation of the carpet page is clearly defined against a ground of fairly simple interlace, now somewhat discoloured through the interaction of the red lead pigment and the sulphur content of the adjacent yellow. The marginal procession of birds is drawn on a large scale. The initial page lacks the sense of overall design seen later in the manuscript, largely because it has no decorative bounding panels. Its text reads: 'Novum opus facere me cogis ex veteri ut post exemplaria scripturarum toto orbe dispersa quasi quidam arbiter [sediam]. . .' (You asked me to make a new work out of the old, so that following the copies of the scriptures scattered about the world, I might set myself up as a judge [where they vary, to decide which of them agrees best with the Greek truth.])

The Matthew carpet page (plate 24) is also based on a very clearly defined cross. Examination of the back of the page shows that the design is built up on a complex grid radiating largely from the 'jewels' in the centre of each segment of the cross. Both the ground of the page and the body of the cross are filled with what at first sight appears to be zoomorphic interlace, though closer examination reveals that only the former includes the heads and legs of birds. The Matthew initial page (plate 25) is bound together into a pattern by the use of marginal bounding panels of pure ornament, keyed into the shape of the principal monogram. The lettering reads: 'Liber generationis Iesu Christi filii David filii Abraham' (The book of the generation of Jesus Christ, the son of David, the son of Abraham).

30. Full-page miniature of the Evangelist Saint Luke, accompanied by his symbol, a winged calf carrying a book ('imago vituli'). The Lindisfarne Gospels, folio 137b.

OVERLEAF:
31. Cross-carpet page introducing the Gospel according to Saint Luke. The Lindisfarne Gospels, folio 138b.

32. Major decorated initial page at the beginning of the Gospel according to Saint Luke. The Lindisfarne Gospels, folio 139.

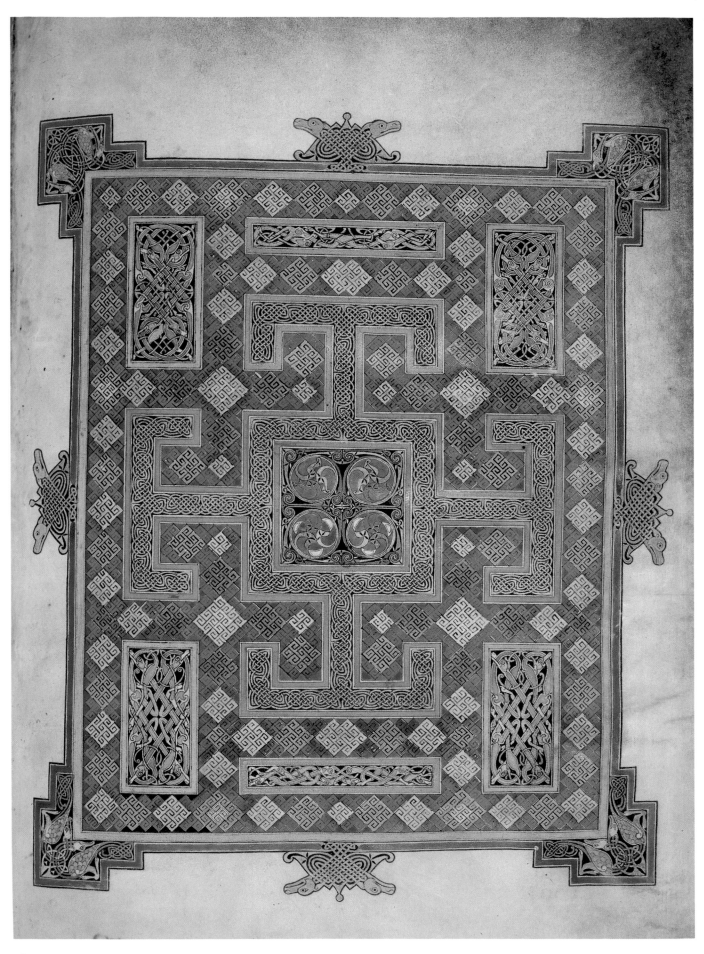

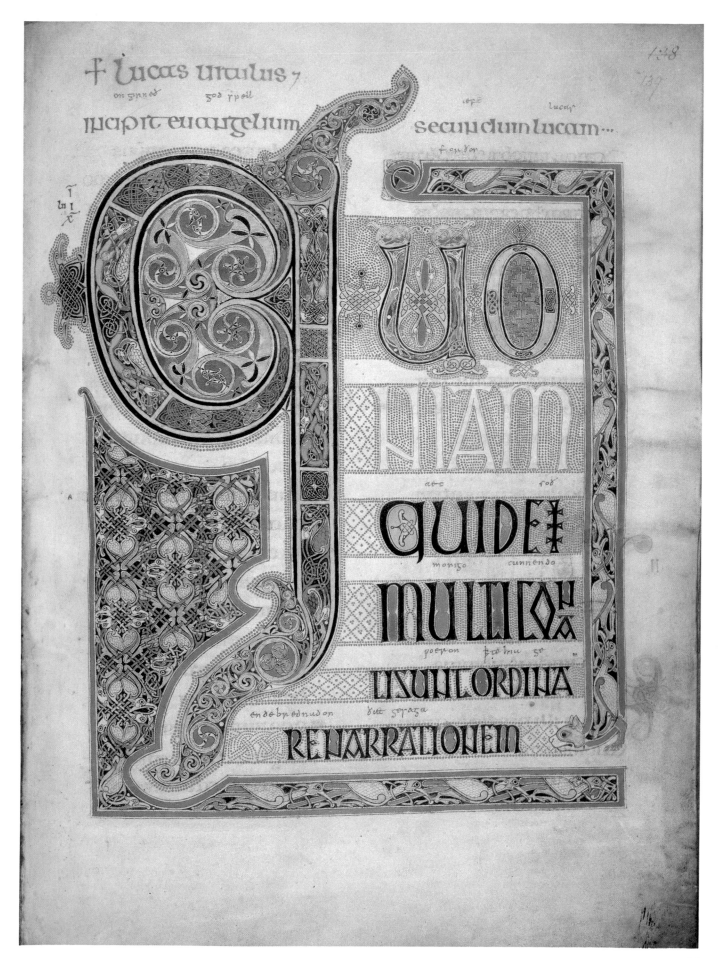

✝ lucas utulus ⁊

on ȝynneð ȝoð rpoll

incipit euangelium

secuncdum lucam···

f. on ðor

QUO
NIAM
QUIDE✝
MULTICO
NA
TISUNTORDINA
RENARRATIONEM

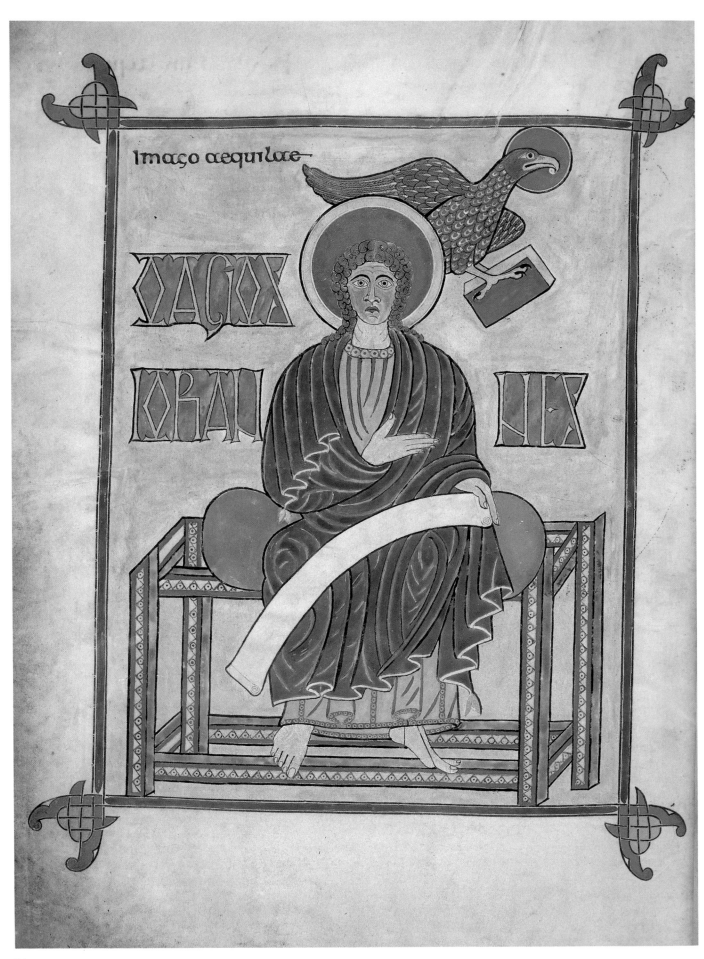

The second initial page in Matthew (plate 26) provides an especially fine example of the use of curvilinear ornament. Its text reads: 'Christi autem generatio sic erat cum esset desponsata mater eius Maria Joseph...' (Now the birth of Jesus Christ was on this wise: When as his mother Mary was espoused to Joseph...).

The range of colours used for the cross-carpet page at the beginning of Mark (plate 28) is fairly restricted, with the emphasis on blue, red and yellow. This gives a deceptive impression of simplicity, though in fact the number of different types of ornament introduced is extensive. The initial page (plate 29) is rather more rubbed than any of the others, this opening having been a favourite for display. It reads: 'Initium evangelii Iesu Christi fili(i) d(e)i sicut scriptum est in Esaia propheta...' (the beginning of the Gospel of Jesus Christ, the Son of God; as it is written in Isaiah the prophet...).

The decorated pages at the beginning of Saint Luke's Gospel (plates 31 and 32) form the most satisfying combination in the manuscript. This is largely due to the success of Eadfrith's design for the initial page, with its great curving letter 'Q' and the almost unbelievably intricate, textile-like panel which follows the contours of its tail. The text of this page reads: 'Quoniam quidem multi conati sunt ordinare narrationem...' (Forasmuch as many have taken in hand to set forth in order...). The range of motifs included in the carpet page is, as in the corresponding page of Mark, extensive, and here gives a more complex impression because of the tiny scale of the basically very simple key pattern with which the ground is filled.

The carpet page to Saint John (plate 34) is full of movement. Its ground is made up of a seething maelstrom of multicoloured birds, against which the almost microscopic interlace which fills the shape of the cross stands out very sharply. The initial page (plate 35) is also extremely complex, and the lines of decorated letters include a number of additional ornaments, one of which, on the second line, is a drawing of a human face, unique in the manuscript except for the Evangelist miniatures. The text on this page reads: 'In principio erat verbum et verbum erat apud d(eu)m et d(eu)s [erat verbum]' (In the beginning was the word and the word was with God and God [was the word]).

Eadfrith had one small idiosyncracy which is apparent on several of the major decorated pages of the Lindisfarne Gospels and which has not been satisfactorily explained. Apparently deliberately, he several times either left a small part of the design unfinished or introduced into it a detail at odds with the remainder of the page. On the first cross-carpet page (plate 19) two small patches of the interlace above the cross, which should be red, are left uncoloured. On the cross-carpet page preceding Matthew (plate 24) one of the birds in the lower right-hand quarter of the design has a spiral joint, though all the others are simply coloured. The Matthew initial page (plate 25) is incomplete, the 'er' of the first line being only partially painted. On the cross-carpet before John (plate 34), a bird in the top right-hand quarter has wings striped blue and pink, whereas all the others have had these stripes broken down into scales. These gaps and discrepancies are so small that it seems unlikely that they were the results of major interruptions to the work. It seems more feasible to suppose that Eadfrith was practising the humility of avoiding absolute perfection in the mammoth task which he had undertaken.

33. Full-page miniature of the Evangelist Saint John, accompanied by his symbol, an eagle carrying a book ('imago aequilae'). Alone of Eadfrith's Four Evangelists, Saint John is seated facing the reader. The Lindisfarne Gospels, folio 209b.

OVERLEAF:
34. Cross-carpet page introducing the Gospel according to Saint John. The Lindisfarne Gospels, folio 210b.

35. Major decorated initial page at the beginning of the Gospel according to Saint John. The Lindisfarne Gospels, folio 211.

7. THE SMALLER INITIALS

In addition to its sequence of great illuminated pages, the Lindisfarne Gospels contains a hierarchy of lesser decorated initials. These appear on the text pages throughout the manuscript and are graded in accordance with the significance of the material which they introduce.

The simplest initials are merely the initial letters appropriate to Eadfrith's insular majuscule script, enhanced on occasion by additional ink contour lines. They are picked out by patches of colour, usually green or yellow, and are often outlined in the characteristic red dots. Some of this work may have been entrusted to an assistant. The red dots certainly seem to be associated with the work of the rubricator, who added the headings written in red (see p. 26). Good examples of these little initials appear on the beatitudes page of Saint Matthew's Gospel (folio 34; plate 8).

More ambitious in design are the initials used to introduce particularly important sections in the lists of liturgical readings. The most attractive of these, both on the same page, occur among the introductory material preceding Saint John's Gospel (folio 208; plate 9). These two initials, particularly the 'D' in the left-hand column, are very delicately drawn and coloured, the pigments being purple, yellow and green, surrounded by the inevitable red dots.

The largest and most splendid of the minor initials are reserved for the the prologue to Saint Jerome's commentary on Matthew and the letter of Eusebius to Carpianus, both at the beginning of the book, and for the 'argumentum' and 'capitula lectionum' preceding each of the Gospels (see above, p. 17). These are expanded to the height of several lines of the text and are followed by lesser decorated capitals, just as the great initial at the beginning of each Gospel is followed by a page full of decorated words, but on a smaller scale.

In designing these initials, Eadfrith made use of the same ornamental vocabulary as in the major decorated pages. The spirals, the ribbon interlace, the birds and the animals are all in their turn introduced. The red dots, which are to be expected in connection with initial letters in an insular manuscript, are used not just to outline his letter forms but to provide a background of soft colouring against which those forms stand out. Because they are overshadowed by the cross-carpets and the grand initial pages at the beginning of each Gospel, these smaller examples of Eadfrith's work tend to be overlooked. Of the four specimens reproduced here only one, the third, has previously been published in colour, and that is included in the facsimile edition of 1956.

The first of our four specimen initials is the 'P' which precedes Saint Jerome's preface to the commentary on Matthew (plate 36). It is succeeded by the remainder of his opening word, 'plures', with a bird's head introduced into the following capitals as well as into the initial itself.

36. Initial P at the beginning of Saint Jerome's Preface to the Four Gospels (actual size). The Lindisfarne Gospels, folio 5b (detail).

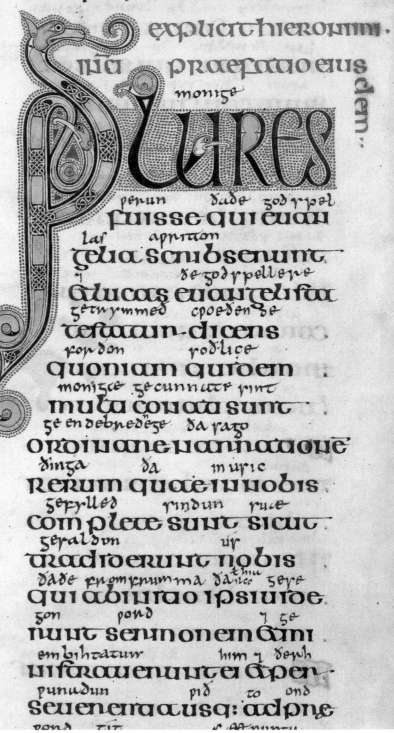

du ʒetreoppeaʒtnʒ ʒemyndʒu
UALEAS AMEN UENIS
mineſ papu du eadʒu
MEI PAPA BEATISSIME
EXPLICIT HIERONIMI
siuʒ **PRAEFATIO EIUS**
moniʒe
PLURES
perun dade ʒod rpal
FUISSE QUI EUAN
laſ apprton
GELIA SCRIBSERUNT
ʒe ʒod rpellore
ALUCAS EUANGELISTA
ʒetrymmed cpoedenʒe
TESTATUR DICENS
ron don rodlice
QUONIAM QUIDEM
moniʒe ʒecunnutr rint
MULTA CONATA SUNT
ʒe en debnedeʒe da raʒo
ORDINARE NARRATIONE
dinʒa da muric
RERUM QUAE IN NOBIS
ʒefylled rindun rue
COMPLETAE SUNT SICUT
ʒeraldon ur
TRADIDERUNT NOBIS
dade rnonrnumma danco ʒeye
QUI AB INITIO IPSIUIDE
ʒon pond y ʒe
NUNT SERMONEM MINI
embihtatur him y dewh
UISTRATI ENUNT EI APER
punudun pid to ond
SEUENERIT AUSQ: ADPRE

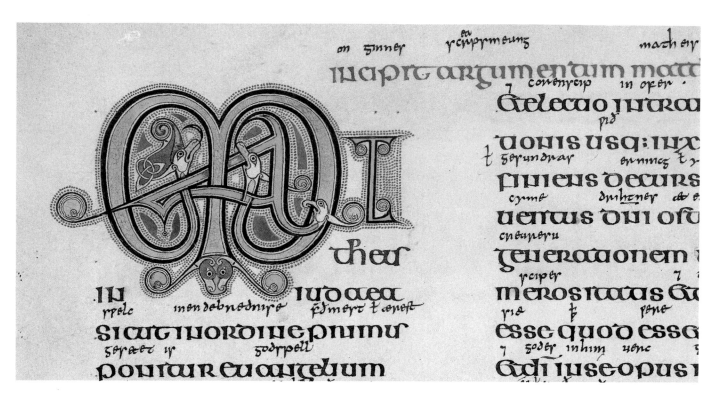

The second is a monogram rather than an initial, comprising the 'MA' of 'Mattheus' at the beginning of the 'argumentum' to Saint Matthew (plate 37). The main letter is made up of two great bows, and five animal heads are introduced, two of them combined at the foot of the monogram to form a single face.

The third initial is again an 'M', opening the 'argumentum' to Mark with the word 'Marcus' (plate 38). The form of this 'M' is quite different from the earlier one and its design is much more elaborate, for there are elongated animal forms, painted in very delicate colours, inside the outlines of the letter as well as on the ground which it

37. Monogram MA at the beginning of the 'argumentum' to Saint Matthew's Gospel (actual size). The Lindisfarne Gospels, folio 18b (detail).

38. Initial M at the beginning of the 'argumentum' to Saint Mark's Gospel (actual size). The Lindisfarne Gospels, folio 90 (detail).

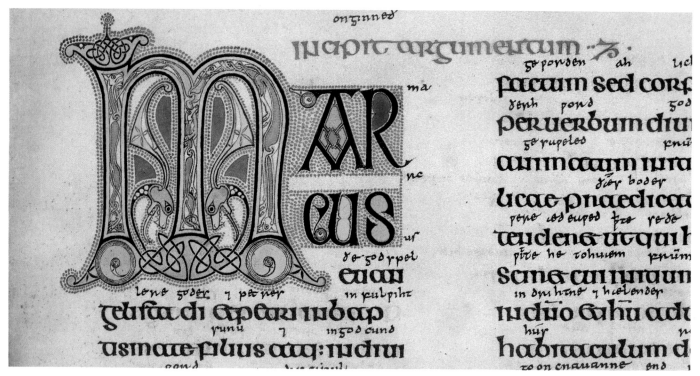

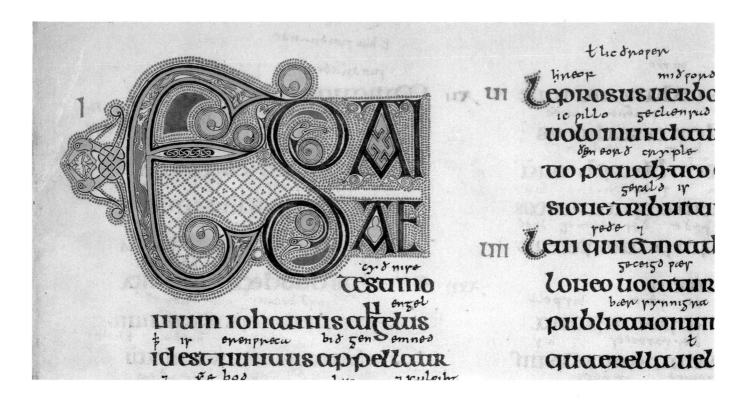

39. Initial E at the beginning of the 'capitula lectionum' to Saint Mark's Gospel (actual size). The Lindisfarne Gospels, folio 91 (detail).

encloses. The remaining five letters of Saint Mark's name are, like those on the major initial pages, enhanced with patches of colour against their background of red dots.

The last of our four initials is the 'E' with which the 'capitula lectionum' to Mark begins (plate 39). The main letter, like the 'M' of 'Marcus', has delicately painted animal forms within its outlines. Two bird heads as well as patches of colour are used to decorate the following letters, which complete the word 'Esaiae' (Isaiah). In the left-hand margin is a decorative motif very like those which occur on the frames of the cross-carpet pages, and this provides two fine specimens of one of Eadfrith's more distinctly legendary-looking creatures, an almost duck-like head with long rows of predatory teeth.

Of the insular Gospel books described in the previous chapter, only one, the Durham Gospels, has minor initials approaching the beauty of those in the Lindisfarne Gospels (plate 13). One other contemporary manuscript, a collection of canons apparently written and decorated in Northumbria, though it was in Cologne as early as the eighth century (Dombibliothek, Köln, cod. 213), is also comparable. Eadfrith stands at the beginning of the development of the highly decorated text initial, an aspect of manuscript illumination which was to become one of the great strengths of English book-painting. About half a century after the making of the Lindisfarne Gospels one of Eadfrith's Northumbrian countrymen took a very significant step forward, when he produced what has a good claim to be the earliest historiated initial (that is, an initial enclosing an illustration relating to the text) in European illumination. This initial, made up of a decorated outline filled with interlace which would be quite at home beside Eadfrith's own work, contains a 'portrait' of Pope Gregory the Great, who sent Saint Augustine to preach the Gospel to the heathen English in 596, and occurs in the second oldest surviving copy of Bede's *Ecclesiastical History*, made at Wearmouth–Jarrow in or about 746 (Leningrad, State Public Library, Q.V.I. 18, fol. 26).

8. SOME COMPARISONS

The creator of the Lindisfarne Gospels was not an isolated genius, producing his great masterpiece in an otherwise dark age. The seventh and eighth centuries were among the most artistically productive in the whole of English history, especially in Northumbria, where the two or three decades on either side of the year 700 were truly a golden age. From this period we still have many surviving examples of book painting, jewellery, metalwork, sculpture and building in stone. There is also a literature, both in Latin and in Anglo-Saxon, and ample evidence of outstanding scholarship, especially in the works of the Venerable Bede.

. Events and personalities of the time are familiar from Bede's *Ecclesiastical History of the English People,* which he completed in 731 and for which he had sought material from friends and correspondents all over England and from as far afield as the papal archives in Rome. He provides a detailed account of the years which produced the Lindisfarne Gospels and was, as we have already seen, personally acquainted with Eadfrith himself. Other historical material is preserved in contemporary lives of local saints, in accounts of the Anglo-Saxon missions to the pagan parts of Europe during the eighth century, and in the collected correspondence of individual personalities, particularly that of Saint Boniface, martyred for the faith in Frisia in 755.

In recent years the written evidence has been increasingly supplemented by evidence from archaeological excavations, and particularly from finds on two sites, both of them well known from the pages of the *Ecclesiastical History.* The first of these is Yeavering (Bede's 'Gefrin'), the Northumbrian royal village at the foot of the Cheviot Hills, about 12 miles south-west from the coast opposite Holy Island. It was at Yeavering that Northumbria's first Christian missionary, Saint Augustine's companion Paulinus, baptized converts in the River Glen for a period of 36 days in 626. Outlines of buildings on the site were identified from crop marks revealed by aerial photography. Excavation uncovered traces of a large complex of wooden buildings, including an extraordinary wedge-shaped grandstand, which must have looked like a section cut from a Roman ampitheatre and which may have been intended as a meeting place for the Northumbrian moot. The second outstandingly important site is the monastery at Jarrow, Bede's own home for almost the whole of his life, where it has proved possible to reconstruct the appearance of the stone-built monastery much as it was in Bede's time.

In the south of England all other discoveries have been overshadowed by the treasures from the ship burial at Sutton Hoo in Suffolk, which was totally unsuspected before the summer of 1939. These are now in the British Museum, and are still today in the process of full-scale publication and evaluation. The jewellery and other items recovered from the site, which is thought to mark the burial place of an

East Anglian king, probably Raedwald, who died about 625, have shed an entirely new light on the artistic achievement and capabilities of early seventh-century England.

Northumbria was by no means cut off from the rest of Britain, nor from Europe. The establishment of Christianity in the kingdom immediately introduced two very strong strains of outside influence into the area, both of which we have already recognized as contributing to the textual and artistic contents of the Lindisfarne Gospels. One strain came from the Mediterranean, firstly through Saint Paulinus and later by means of the close, direct contacts with Rome itself which were fostered by Saint Wilfrid and by Benedict Biscop and Ceolfrith of Wearmouth–Jarrow. The major results of this influence can be identified in contemporary Northumbrian art and scholarship, its outstanding achievement being the Codex Amiatinus, so long believed to be of Italian origin. The other strain came from Ireland through the Iona mission of Saint Aidan in 635, and relations between the two countries remained extremely close, even after the Synod of Whitby in 664 had diminished direct Irish influence on the Northumbrian Church.

There are many recorded instances of influential Northumbrians, both churchmen and members of the ruling family, visiting Iona or Ireland for periods of study. The outstanding example of a man educated in Ireland but at the same time ready and eager to take advantage of the new books and learning brought in from the Continent is Aldfrith, who was king of Northumbria from 685 to 705, his reign thus spanning an appreciable part of the careers of both Eadfrith and Bede. Aldfrith was the illegitimate son of King Oswiu and an Irish princess. While in exile in Ireland during the reign of his half-brother Ecgfrith, the patron of Wearmouth and Jarrow, he had received an Irish education and even spoke the Irish language. When he succeeded to the throne on Ecgfrith's death in battle at Nechtansmere, he rapidly showed himself to be fully appreciative of the new learning imported from Italy, but at the same time maintained contact with his old teachers. It was to Aldfrith that Adamnan of Iona presented his account of the Holy Places in Palestine, and the king soon circulated copies of this 'for lesser folk to read', to the great delight of Bede and his contemporaries.

Both England and Ireland drew on the same Celtic artistic legacy, into which they assimilated the Germanic motifs brought by the Anglo-Saxon settlers, and constant interchange produced such similar results that it is extremely hard, in the absence of written corroborative evidence, to distinguish the Irish from the Northumbrian, particularly in book painting and in metalwork. This subject arouses strong passions among partisan scholars, but the cautious tend to adopt some suitably ambiguous blanket description such as 'insular' or 'Hiberno-Saxon' when dealing with it. The histories of the Lichfield Gospels of Saint Chad, which had migrated to South Wales from its as yet unidentified birthplace by the early ninth century, and of the Lindisfarne Gospels itself, which could very well have been taken across to Ireland at the end of the ninth century, supply ample evidence of the way in which objects could be moved from place to place, even quite early in their existence.

In the eighth century it was Northumbria that provided, through the activities of the missionaries on the Continent, a strong strain of artistic and cultural influence on others. By the time the Vikings made their first raid on Lindisfarne in 793, one of the greatest of these English emigrants, Alcuin of York, a pupil of Archbishop Egbert who

OVERLEAF:
40. Enlarged detail from the cross-carpet page introducing Saint Matthew's Gospel. The area shown lies in the lower right-hand quarter of the page. The highlight which runs across the top of the picture marks the line of the spine of the animal from which the vellum came. The Lindisfarne Gospels, folio 26b.

41. The Gospels of Saint Chad. Enlarged detail from the cross-carpet page (p. 220) which introduces Saint Luke's Gospel. An area similar to that in the most closely related of the Lindisfarne Gospels cross-carpet pages (previous plate) is shown. Delicate shades of lilac and lavender are especially characteristic of the work of the Saint Chad artist. These appear too pink in this plate because the pigment used does not reproduce accurately on modern colour film. The same colours are similarly misrepresented on a number of the plates from the Lindisfarne Gospels itself (*Lichfield Cathedral, Chapter Library*).

63

42. The Gospels of Saint Chad. The cross-carpet page and major initial page (pp. 220–221) at the beginning of Saint Luke's Gospel. These should be compared with the cross-carpet pages preceding Saint Jerome's letter (plate 19) and Saint Matthew's Gospel (plate 24), and with the major initial page at the beginning of Saint Luke's Gospel (plate 32) in the Lindisfarne Gospels (*Lichfield Cathedral, Chapter Library*).

had, in his turn, been a disciple and friend of the Venerable Bede, had already for more than a decade been established at the court of Charlemagne. His position, first as tutor to the royal family and later as abbot of Saint Martin's of Tours, allowed him to play a leading role in the Carolingian renaissance.

Within the historical and artistic framework of the period, the Lindisfarne Gospels has a particularly important place. Firstly, it is a work of outstanding beauty and sophistication, displaying all the various elements which combine to make up the distinctive style current in seventh-century England. Secondly, thanks to Aldred's tenth-century colophon, we know exactly where, when and by whom it was made. It thus becomes a touchstone for the assessment of all other works of art of the period.

There can be no doubt of Eadfrith's technical mastery of the craft of book production, nor of his flair for subtle design. Even in their complete and undamaged state, none of the other Gospel books directly comparable with the Lindisfarne Gospels can have attained quite the same consistent perfection. It seems likely that the artist of the Gospels of Saint Chad, whose work is in several ways the closest, had actually seen and studied Eadfrith's great book. The outline of his surviving cross-carpet page (plate 42) is an amalgamation of the cross shapes in Eadfrith's first (plate 19) and second (plate 24) carpets, and his combination of animal and bird interlace is close in intention to Eadfrith's. But the very narrow and much more violently contorted tendrils between his individual birds and beasts are loosely woven, revealing larger areas of dark background than Eadfrith permitted (plates 40 and 41). The ornamental appendages to the frame, also derived directly from Eadfrith's Matthew carpet page, are more numerous and far fussier (plate 42). On the 'Quoniam' page he has abandoned the fluid, sweeping curves of Eadfrith's initial (plate 32), to which the curves of border and panels are fitted. Instead he pro-

duces a very geometrical design (plate 42), with hard corners even within the stem of the initial 'Q', surrounded by a heavy, four-square border. Although this border too begins and ends with the head, feet and tail of a bird-filled beast, it entirely lacks the charm of Eadfrith's hunting cat. Where Eadfrith has varied his decorated capitals from large at the top of the page to relatively small on the sixth and lowest line, at the same time trying to ensure that their shapes make it possible for the words to be read, the Saint Chad artist has produced four lines of letters of exactly similar proportions and with a minimum of individual characteristics. The overall impression given by reproductions of the decorated pages of the Lichfield manuscript is one of heaviness, though in the original this is somewhat mitigated by the very delightful colouring, in which lilac and lavender play a leading part.

In many ways most closely related to the design and execution of the ornament in the Lindisfarne Gospels is the design and ornament of the Tara Brooch, now in the National Museum of Ireland in Dublin (plate 44). Unfortunately we have no direct indication of the date or place of origin of this marvellous piece of jewellery. It was found in 1850 on the seashore in County Meath, not very far from ancient Tara, though its name was the invention of the Dublin jeweller who acquired it and sold replicas of it in London at the Great Exhibition in 1851. It is quite small, about 3 inches in diameter, but both back and front are heavily encrusted with the most intricate and delicately executed ornament, which conveys a richly polychrome effect, not merely because of the introduction of coloured studs but also through the interplay of areas of gold, silver and copper. The back of the Tara Brooch is particularly related to the Lindisfarne Gospels. On it appear panels of simple and of animal interlace, a long border filled with curvilinear patterns, two three-sided panels of curvilinear motifs, and a further border enclosing a procession of interlaced birds, very close indeed to those painted by Eadfrith. The three-sided panels and the bird border are shown in more detail in an enlarged photograph (plate 46), taken when the brooch was undergoing restoration in the British Museum research laboratory in the early 1960s.

The one surviving major (though badly rubbed) decorated page in the Durham Gospels (plate 45), which may be slightly earlier than the Lindisfarne Gospels or is possibly the work of an artist of an older generation, makes very little use of curvilinear patterns. A few tiny examples occur at the very base of the initial, but even there the slightly larger circular areas which we might expect to see treated in this way are actually filled with arrangements of birds' heads. It seems at first sight that birds are the mainstay of the Durham Gospels illuminator, as the entire framework of his great monogram is filled in with interlaced creatures possessed of prominent beaks. However, closer scrutiny reveals that these creatures have four limbs, extensions of which are used for the very open interlace which fills the spaces between them. They are very definitely the invention of an artist and convey nothing of the feeling for nature, however much it is adapted for its purpose, that comes through strongly in Eadfrith's work.

The curvilinear patterns found in the manuscripts have another important parallel in metalwork. Very similar designs are found on the decorative enamel escutcheons (small ornamental plaques) of hanging bowls. These bowls, while they are apparently of Celtic workmanship, are usually found in the context of pagan Anglo-Saxon graves. About 70 examples are known, and they have been recovered in conjunction with other materials ranging in date from the fifth to the seventh

OVERLEAF:

43. Enlarged detail from the second major initial page in Saint Matthew's Gospel, showing the curvilinear ornament in the bow of the main letter. The Lindisfarne Gospels, folio 29.

44. The Tara Brooch, reverse side (*National Museum of Ireland, Dublin*).

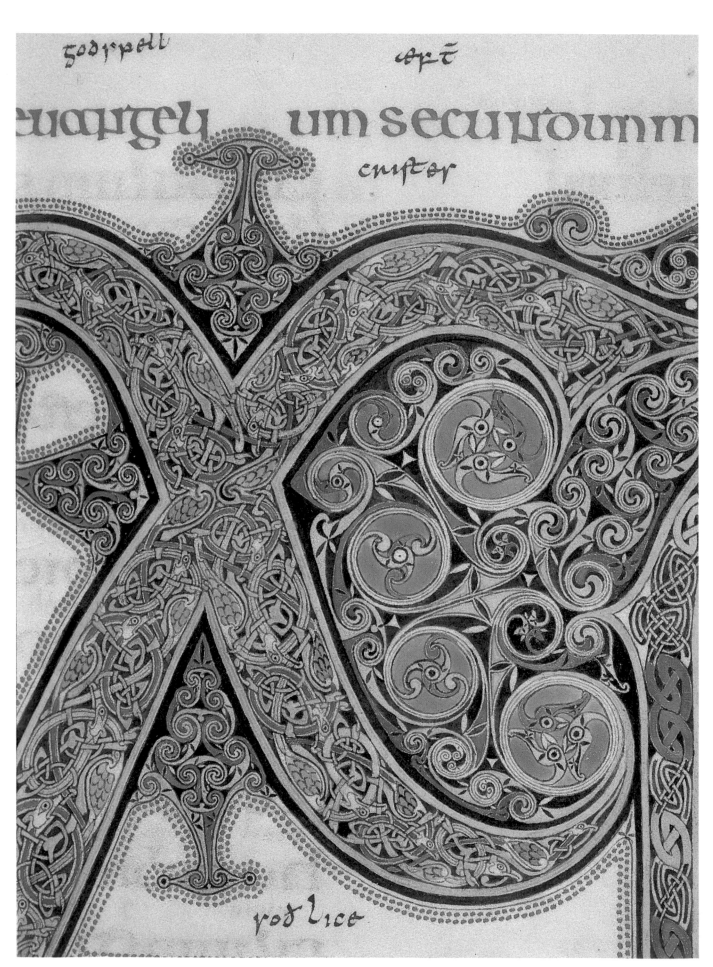

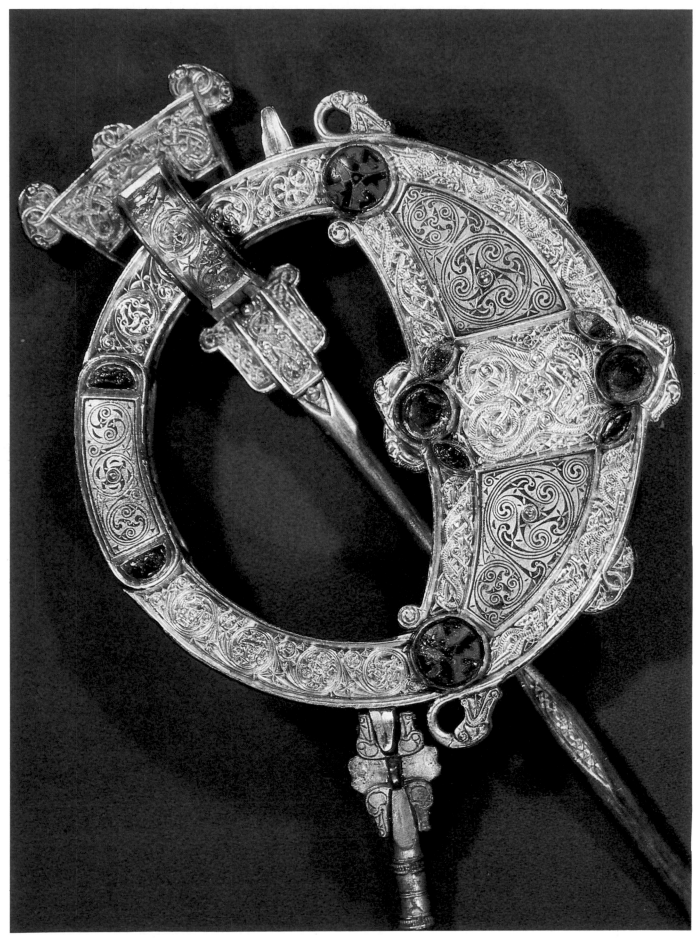

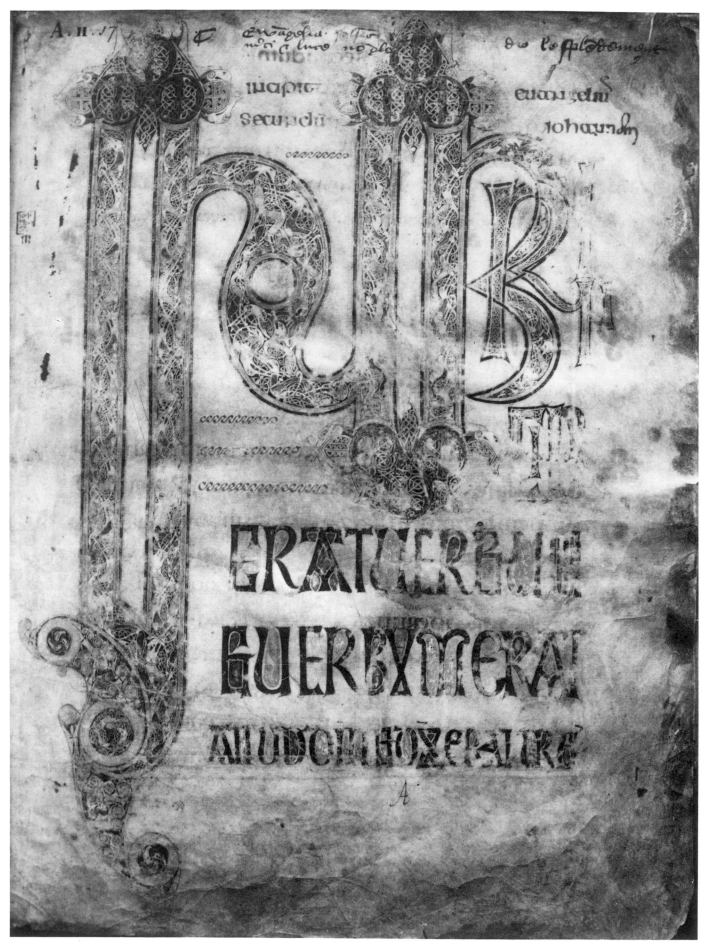

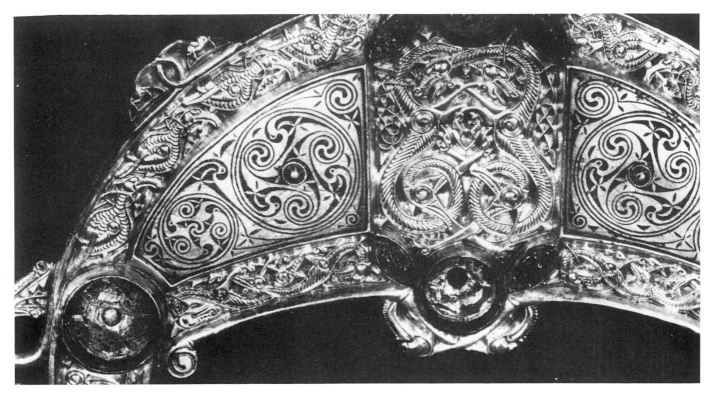

century. No one has as yet produced an entirely convincing ex-
planation of their function, though it has been suggested that they
were hanging lamps or containers for water, possibly holy water. It
does, however, seem likely that they were part of the trappings of
Christian churches in the Celtic west of the British Isles and that the
Anglo-Saxon invaders acquired them as loot. The very finest hanging
bowl yet found was among the treasures recovered from the Sutton
Hoo ship burial. It has six escutcheons on the outer surface, three of
them square and purely decorative and the other three round and
attached to the rings by which the bowl would be hung (plate 48).
They are decorated with coloured enamels and with insets of mille-
fiori glass. Inside the base of the bowl is another round escutcheon
from which rises a little movable fish on a pedestal. The Sutton Hoo
bowl must have been a much cherished treasure, for it was provided
with a decorated silver patch after it came into Anglo-Saxon hands.

In metalwork the red dots used by Eadfrith and his contemporaries
to emphasize the outlines of their initial letters become tiny punch
marks on an otherwise smooth ground. The technique is seen used to
great effect on the Ardagh Chalice, a superb example of the jeweller's
craft, which was found among a hoard of lesser items in County
Limerick in 1874. It is now in the National Museum of Ireland. Its
restrained yet sophisticated decoration, which includes coloured studs
and little panels of gold filigree work, has much in common with the
work seen on the Tara Brooch. The overall effect is, however, much
less blatantly rich because of the large areas of plain silver against
which the decoration appears. On the bowl of the chalice the names of
the twelve apostles are written against a background of tiny indenta-
tions (plate 50), the result bearing a very strong resemblance to the
work on some of the major initial pages in the Lindisfarne Gospels
(plate 49). The general relationship of the Ardagh Chalice to North-
umbrian craftsmanship from the years around 700 is recognized by
pro-Irish and pro-English scholars alike, and it is unlikely — and
perhaps unnecessary — that we shall ever be entirely certain on which
side of the Irish Sea the man who made it lived.

Scholars writing about early insular manuscripts in the years before 1939 were unable to draw attention to one of the most spectacular works of art which can be compared with them. This is the superb pair of gold and garnet shoulder clasps from Sutton Hoo, part of an assemblage of jewelled trappings and personal ornaments entirely without parallel from any other site. So rich are the objects found in the ship burial that it can only have been the resting place of one of the kings of East Anglia. Coins found in association with a jewelled purse lid suggest a date of about 625 for the deposit, and a mixture of pagan and Christian objects amongst the grave goods points to a similar date. The best candidate to be the man honoured with so sumptuous a burial is Raedwald, the powerful East Anglian king who died in or about 625. Raedwald had accepted the Christian faith early in his reign, under the influence of King Ethelbert of Kent, who had received Saint Augustine and his companions in 597. However, he subsequently returned to his old religion, and Bede tells us that he went so far as to set up altars to Christ and to the heathen gods under the same roof. East Anglia was re-converted by his successor, and the interesting suggestion has recently been made that the apparent absence of a body in the Sutton Hoo grave could be due to the removal of Raedwald's remains from their pagan resting place to a consecrated site, better befitting a king who had once been a baptized Christian.

Each of the Sutton Hoo shoulder clasps is made of two pieces, the main rectangular field of each filled with a colourful stepped design of garnets and millefiori glass surrounded by a border of animal interlace (plate 52). The very thin slices of garnet are laid over patterned gold foil, adding to the intricacy of the design. The resemblance to a decorated carpet page is very clear, both in detail and in general conception. A multicoloured stepped design, its cells seemingly di-

vided by walls of metal, is used as a centrepiece for the cross-carpet page at the beginning of Saint Mark in the Lindisfarne Gospels (plate 51). The simpler carpet pages in the Book of Durrow, with their bold, large-scale motifs and wide borders, underline the relationship. A further link with the Book of Durrow may be found in the border of animal interlace surrounding the central panel, whose long-nosed, almost beaked animals are first cousins to the long-snouted creatures on the Saint John carpet page of the manuscript.

The Book of Durrow is much simpler than the Lindisfarne Gospels and seems to represent an earlier stage in the development of insular book decoration, in which most of the elements are already present but are not yet thoroughly mingled (plate 53). A different kind of simplicity is displayed in the Echternach Gospels (plate 54), which seems to have been deliberately planned for speed of execution rather than to represent an early stage of development. Although only one full page of decoration precedes each of the Gospels in this book, its artist has contrived to combine in them not only a representation of the appropriate Evangelist through his symbol but also the feeling of a cross-carpet page, implied in the simple coloured bars which break up the background into a variety of different shapes and sizes of uncoloured vellum.

In Eadfrith's work the panels of different shapes and sizes which appear both on the fully decorated pages and within the outlines of the great initial letters are almost always filled with one or another variety of ornament. He showed enormous skill in adapting his motifs to fill the oddest of shapes. Panels of ornament in a totally different medium, but in design often closely resembling manuscript work, are found in the decoration of carved stone crosses, many of them apparently dating from the late seventh and the eighth centuries. Most of the crosses are entirely undocumented, their purpose and origin forgotten. Some of them may have been raised to commemorate important people and events. We know from Bede that the sainted King Oswald of Northumbria raised a great cross of wood to mark the place where he was about to engage in battle with the heathen at 'Heavenfield', near Hexham, in 634, and that he and his army knelt in prayer before it before the battle began. Other crosses may have marked traditional meeting places, used in the early days of Christianity as sites for the celebration of Mass, where an itinerant bishop or priest such as Saint Cuthbert would have consecrated the bread and wine on his portable altar. The cross in the churchyard at Bewcastle in Cumberland, some miles north of Hadrian's Wall, seems to indicate such a spot. Although the church and the handful of houses adjoining it are isolated in desolate country, they stand on the site of a Roman fort which was probably a notable landmark in Bede's day. This cross, which includes a long inscription in runes and some figure carvings now very much eroded by centuries of exposure to the weather, has panels of simple ribbon interlace exactly parallel to several of those used by Eadfrith (plate 57). A fragment of a cross from Aberlady, on the southern shore of the Firth of Forth, retains a panel of interlaced birds closely akin to those in the Lindisfarne Gospels, below which is the remains of a panel of the type of key pattern seen in the background to the cross-carpet page preceding the Gospel of Saint Luke (plate 55).

Stone carvings on a large scale have survived where carvings on a smaller scale and in more vulnerable materials have not. A unique relic from the early Christian period in Northumbria is the Franks Casket, a small box made up of panels of whalebone carved with scenes from a mixture of pagan and Christian stories, reminding us

OVERLEAF:
51. Enlarged detail from the cross-carpet page introducing Saint Mark's Gospel, showing Eadfrith's use of a cellular step pattern in the central roundel (for the reverse side of which, see plate 15). The Lindisfarne Gospels, folio 94b.

52. The Sutton Hoo ship burial. Enlargement of part of one of the gold, garnet and millefiori shoulder clasps. The overall design of this ornament is strongly reminiscent of a manuscript carpet page (*British Museum, Department of Medieval and Later Antiquities*).

75

78

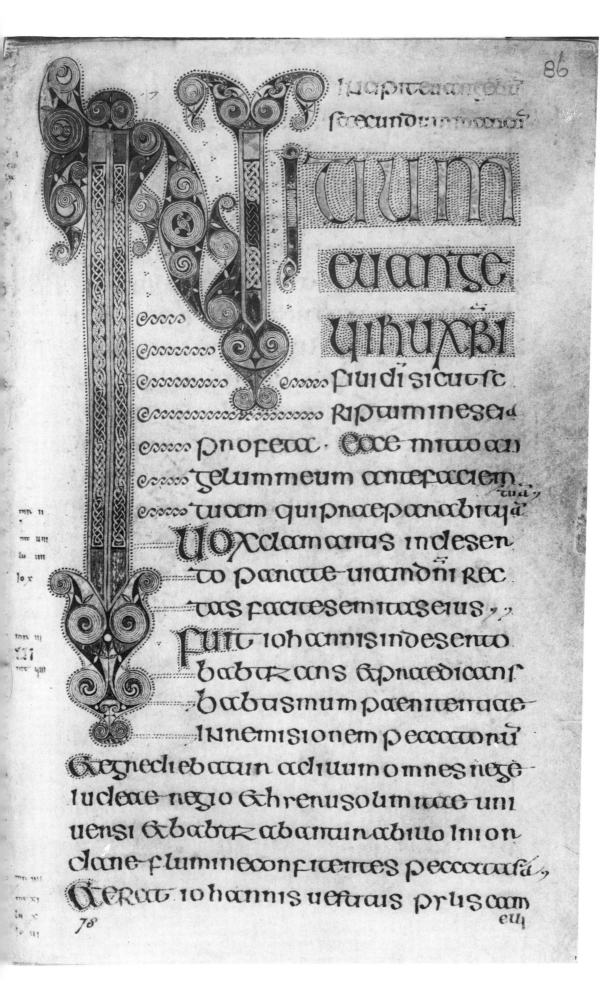

Incipit euangelium
secundum marcum

initium
euange
lii ihuxbi
filii di sicut sc
riptum inesaia
propheta . ecce mitto an
gelum meum antefaciem
tuam qui praeparabit uia

Vox clamantis indesen
to parate uiamdni rec
tas facite semitas eius

fuit iohannis indeserto
babtizans & praedicans
babtismum paenitentiae
inremisionem peccatorum

& egrediebatur adillum omnes rege
iudeae regio & hierusolimitae uni
uensi & babtizabantur abillo iniord
dane flumine confitentes peccata sua
& erat iohannis uestitus pilis cam

53. The Book of
Durrow. Cross-carpet
page and major initial
page at the beginning of
Saint Mark's Gospel.
Trinity College, Dublin,
MS A. 4. 5. (57), folios
85b–86 (*Trinity College,
Dublin*).

58. The Franks Casket. Front panel, carved in whalebone, showing a scene from the story of Wayland the Smith on the left and the Adoration of the Magi on the right (*British Museum, Department of Medieval and Later Antiquities*).

OPPOSITE:
57. The Bewcastle Cross. Panel of knotwork sculpted in stone (*photo: R. J. Cramp*).

OVERLEAF:
59. The Codex Amiatinus. Miniature of Ezra. The book press behind him contains nine books labelled with the titles of Cassiodorus's Novem Codices. Around his feet are strewn the tools of a scribe. This miniature should be compared with the miniature of Saint Matthew from the Lindisfarne Gospels (plate 23), as both derive from the same model. Biblioteca Medicea-Laurenziana, Florence, MS Amiatinus I, folio V.

60. The Gospels of Saint Chad. Miniature of the Evangelist Saint Mark (p. 142), accompanied by his symbol, a lion carrying a book (*Lichfield Cathedral, Chapter Library*).

personal style and added to it the Evangelist's symbol and the mysterious figure peeping round the curtain. It is interesting to compare the Ezra and the Matthew, both of which have recognizably descended from an Italian model, with one of the two surviving Evangelist pictures in the Lichfield Gospels of Saint Chad, that of Saint Mark (plate 60). This figure has some features suggesting a classical model (particularly in the form of the costume, although this has been reduced to a linear pattern), and its feet are every bit as naturalistic as those drawn by Eadfrith himself, but the general impression given by the page is nevertheless barbaric rather than classical. This impression is very much enhanced by the extraordinary 'throne' behind the figure, which looks more like the iron frame from the Belgic burials at Welwyn (now in the British Museum) than the simple footstool of the other two miniatures. The lion symbol above the saint's head is, however, recognizable for what it is, though in appearance it is closer to the Echternach painter's interpretation than to that of Eadfrith. It also lacks the wings and trumpet seen in the Lindisfarne Gospels.

The most directly relevant set of Evangelist symbols is that on the lid of Saint Cuthbert's coffin, which is preserved at Durham Cathedral with other relics from the grave. The coffin is a carved chest, made out of oak, which was prepared to receive the saint's remains at the time of the elevation in 698. Although by the time the tomb was investigated during the nineteenth century, the coffin had disintegrated into a series of broken and distorted lumps of wood, enough was recovered for the whole of the decoration to be reconstructed and studied. The carving consists of very simple incised lines. On one long side of the coffin and at the head are figures of the archangels, on the other side figures of the twelve Apostles. On the panel at the foot is a seated figure of the Virgin, holding the Christ Child. On the lid is a figure of Christ, surrounded by the symbols of the four Evangelists, those of Matthew and Mark over his head and these those of Luke and John beneath his feet (plate 61). Their resemblance to the symbols painted into the

84

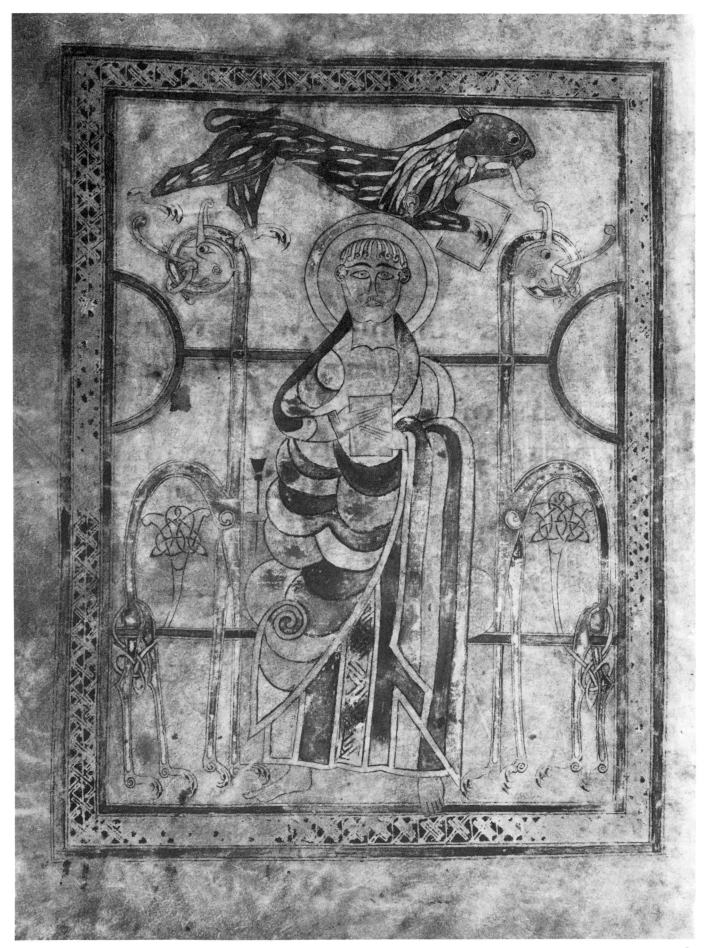

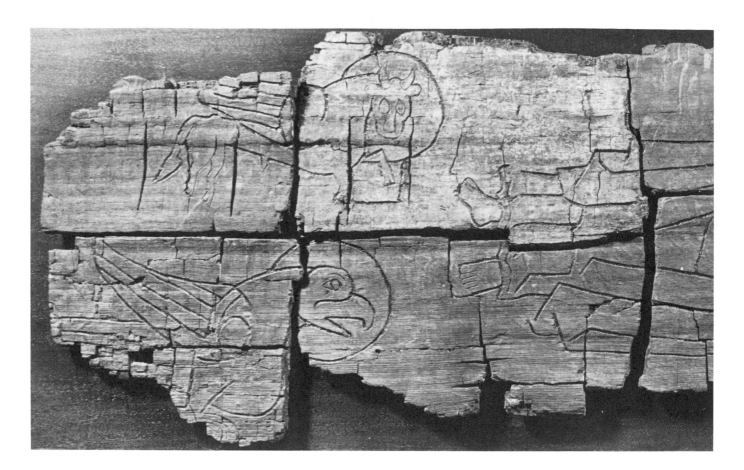

Lindisfarne Gospels, which must have been in the making at the same time as the coffin, is very striking, although the medium and technique are so different.

So much fine material has survived the twelve or thirteen intervening centuries that we are at least able to make some assessment of the skill and artistry of Anglo-Saxon craftsmen working in many different fields. How much more has been lost we shall never know. The Viking raids, which began in the late eighth century and gradually affected the whole of England, hit Northumbria very hard and were to leave the most famous of her monasteries derelict, Lindisfarne and Jarrow among them. Had Eardulf and his community neglected to remove the body of their saint and all the treasures of their monastery to safety, a high proportion of the works of art described in this book, including the Lindisfarne Gospels itself, might very well have been lost to us.

61. Saint Cuthbert's coffin. Part of the lid, showing the outlines of the symbols of Saint Luke and Saint John, the calf and the eagle, incised in the wood (*Durham Cathedral Library*).

9. THE LATER HISTORY OF THE MANUSCRIPT

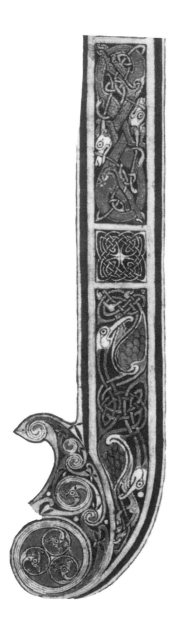

The relics of Saint Cuthbert, together with the other treasures of Lindisfarne, including the Gospels, came to rest at Chester-le-Street in 883, some seven years after Bishop Eardulf and his community had fled from Holy Island. Chester-le-Street, which is about six miles north of the City of Durham, was built within the ruins of a Roman camp, no doubt much more obvious in the ninth century than it is today. The medieval parish church, dedicated to the Virgin Mary and Saint Cuthbert, apparently occupies what was once the site of the Roman headquarters building. Saint Cuthbert's community remained there for more than a century until, in 995, news of fresh Viking incursions uncomfortably close at hand seemed to necessitate a further move, this time southwards to Ripon. A few months later, on the return journey, the saint miraculously indicated that he wished a new home to be established for him at Durham.

The old city of Durham stands on steeply sloping ground, almost encircled by a loop of the river Wear. It is, like Holy Island, a natural stronghold. The body of Saint Cuthbert has remained there until the present day, except for a very brief period in 1069-70 when the last Saxon bishop, Ethelwine, fled with the relics back to Lindisfarne in fear of the punitive expedition to the north led by the new Norman king, William the Conqueror (plate 62). The second Norman bishop of Durham, William of Saint Calais (Carilef) in 1083 replaced with Benedictine monks the by then largely secular community which he had found attending the cathedral and shrine, and a dependent priory was established on Holy Island. In 1093 he laid the foundation stone of the immense Romanesque cathedral which stands to this day (plate 64). In 1104, in the time of his successor, Bishop Ranulph Flambard, the building of the cathedral was far enough advanced for Saint Cuthbert's relics to be solemnly translated to their new setting at the high altar, where the shrine became the focal point of the church for pilgrims. During the translation the coffin was again opened and the saint's body seen still to be undecayed. It is clear from the account given by Symeon of Durham, who wrote shortly after the event, that at this time the Lindisfarne Gospels was still among the treasures associated with the saint.

There is no certain reference to the history of the manuscript during the remainder of the Middle Ages. What could be a description of it, as 'the book of Saint Cuthbert which fell into the sea', occurs in a list of the few books at Lindisfarne Priory in 1367, suggesting at least a temporary visit to its former home, but it is also possibly identifiable with an item in the Durham Cathedral relic list of 1383. When the Reformation came, the priory on Holy Island was dissolved in 1537 and the cathedral priory itself suffered the same fate about two years later. Henry VIII's commissioners seized the treasures of Saint Cuthbert's shrine, and the body of the saint, yet again seen to be intact,

Origin and development of handwriting in 1784, leaves no doubt of the importance of the Lindisfarne Gospels as one of the outstanding works of art to have survived from the early Middle Ages. However, this particular book has never been regarded merely as a museum curiosity, of interest only to scholars and connoisseurs, but has kept something of the mystique of a holy relic, even into the twentieth century. Strong antiquarian interest during the nineteenth century inspired two investigations of Saint Cuthbert's tomb. The first, in 1827, was particularly concerned to show that the incorruptibility of Saint Cuthbert was a papist myth, 'invented for interested purposes in a supertstitious age'. The second (rather more scientifically conducted) took place in 1899. Fragments of the original oaken coffin of 698, together with such personal possessions as the saint's portable altar, pectoral cross and ritual comb, were recovered and may nowadays be seen in the cathedral treasury at Durham. During the same period Durham did not forget the Gospels. In March 1852 the octogenarian bishop, Edward Maltby, wrote to the British Museum and offered 60 guineas to pay for a new and more fitting binding for Saint Cuthbert's book. It is possible that he had seen and admired replicas of the Tara brooch, on sale at the Great Exhibition in the previous year. The offer was accepted and the work placed in the hands of Smith, Nicholson and Co., silversmiths in Lincolns Inn Fields, who endeavoured, with some success, to produce a design based upon motifs found in Eadfrith's own work. The result (plate 63), which has apparently never been published and which is invisible to visitors because the Gospels is always open in its exhibition case, is a magnificent piece of Victorian archaeological revival metalwork. However, Sir Frederic Madden, who was Keeper of Manuscripts in 1852 and who viewed the

64. The west front of Durham Cathedral, final resting place of the relics of Saint Cuthbert and one-time home of the Lindisfarne Gospels (*photo: the author*).

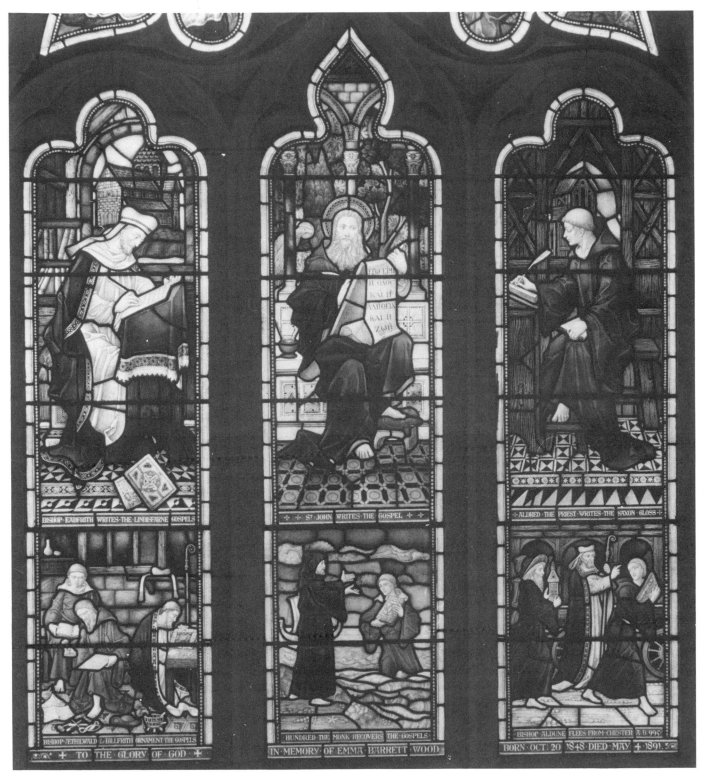

Within the stained glass window, the following inscriptions appear:

BISHOP·EADFRITH·WRITES·THE·LINDISFARNE·GOSPELS

St·JOHN·WRITES·THE·GOSPEL

ALDRED·THE·PRIEST·WRITES·THE·SAXON·GLOSS

BISHOP·ÆTHILWALD·&·BILLFRITH·ORNAMENT·THE·GOSPELS

HUNRED·THE·MONK·RECOVERS·THE·GOSPELS

BISHOP·ALDHUNE·FLEES·FROM·CHESTER·A.D·995

TO·THE·GLORY·OF·GOD

IN·MEMORY·OF·EMMA·BARRETT·WOOD

BORN·OCT·20·1848·DIED·MAY·4·1891

entire project with great disfavour, thought it '... a complete failure ... The binding is hideous, as it now stands, and the effect wretched enough to bring us into ridicule.'

In more recent years the parish churches of both Chester-le-Street and Holy Island have marked their association with the Lindisfarne Gospels. In the north aisle at Chester-le-Street is a remarkable stained glass window (plate 65), installed in memory of Emma Barrett Wood, who died in 1891. This imaginatively re-creates scenes of Eadfrith and Aldred writing the manuscript, Ethelwald and Billfrith creating the covers, Hunred rescuing it from the sea, and Bishop Aldhune leading

65. Memorial window in the parish church at Chester-le-Street, installed soon after 1891, showing Eadfrith and Aldred writing their contributions to the Lindisfarne Gospels, Ethelwald and Billfrith at work on the binding, Hunred miraculously recovering the manuscript from the sea, and Bishop Aldhune urging his brethren on to their last flight from the Danes in 995 (*photo: Canuck Studios, Chester-le-Street.*).

the flight from Chester-le-Street in 995. In the thirteenth-century church on Holy Island, which is separated from the site of the Anglo-Saxon monastery and the ruins of the later medieval priory by little more than the width of a footpath, the sanctuary is adorned with a large and sumptuous embroidered carpet, copied in detail from the cross-carpet page which precedes Saint Mark's Gospel in Eadfrith's manuscript. This was made by a group of 18 local ladies (plate 66), who devoted two years to the task. It was dedicated in June 1970.

Although it is certain that the Lindisfarne Gospels has not been seen on Holy Island since the end of the Middle Ages, and quite probable that its last appearance there was in 1069, when Bishop Ethelwine and his followers took flight from William the Conqueror, local awareness of the connection with this great treasure is still very much alive. A copy of the facsimile edition of 1956, a gift from the Rockford College Community, Illinois, U.S.A., lies in a glass case in the church, only a few yards from the place where Eadfrith and Ethelwald created it 'for God and for Saint Cuthbert and — jointly — for all the saints whose relics are in the island', almost thirteen centuries ago.

66. Miss Kathleen Parbury with four of the eighteen embroidresses who created the Lindisfarne Gospels carpet for the sanctuary of the parish church of Holy Island (*photo by permission of the vicar of Holy Island*).

BIBLIOGRAPHY

A. SUMMARY DESCRIPTION OF THE MANUSCRIPT

Cotton MS Nero D.iv: The Lindisfarne Gospels

Vellum; ff. 259. 340 × 250 mm. ($13\frac{1}{2} × 9\frac{3}{4}$ inches). Gatherings mainly of eight leaves (for full details the introductory volume to the facsimile edition of 1956, cited below, should be consulted). Latin (about AD 698) with an Anglo-Saxon gloss (mid-10th century). Bound in red velvet, lavishly ornamented with silver and gemstones, 1852-3.

Contents: (1) List of contents in the hand of Sir Robert Cotton's librarian, 17th century, f. 1. (2) Epistle of Saint Jerome to Damasus, ff. 3-5b. (3) Prologue to the Four Gospels, ff. 5b-8. (4) Epistle of Eusebius to Carpianus, ff. 8-9. (5) Eusebian canon tables, ff. 10-17b. (6) Preface ('argumentum') to Matthew, ff. 18b-19. (7) Table of chapters ('capitula lectionum') to Matthew, ff. 19-23b. (8) Table of feast days for lessons from Matthew, ff. 24-24b. (9) The Gospel according to Saint Matthew, ff. 27-89b. (10) Preface to Mark, ff. 90-90b. (11) Table of chapters to Mark, ff. 91-93. (12) Table of feast days for lessons from Mark, f. 93. (13) The Gospel according to Saint Mark, ff. 95-130. (14) Table of feast days for lessons from Luke, ff. 130-130b. (15) Preface to Luke, ff. 131-131b. (16) Table of chapters to Luke, ff. 131-137. (17) The Gospel according to Saint Luke, ff. 139-203. (18) Preface to John, ff. 203b-204. (19) Table of chapters to John, ff. 204-208. (20) Table of feast days for lessons from John, ff. 208-208b. (21) The Gospel according to Saint John, ff. 211-259. (22) Colophon recording the names of those who made the manuscript, in the hand of Aldred the glossator, mid-10th century, f. 259.

Decoration: (1) 16 pages of Eusebian canon tables, ff. 10-17b. (2) Miniatures of the Four Evangelists, ff. 25b, 93b, 137b and 209b. (3) 5 decorative cross-carpet pages, ff. 2b, 26b, 94b, 138b and 210b. (4) 6 major initial pages, ff. 3, 27, 29, 95, 139 and 211. (5) Lesser initials for prefaces etc., ff. 5b, 8, 18b, 19, 24, 90, 91, 93, 95b, 130, 131, 131b, 136b, 137, 139b, 203b, 204, 208 and 211b.

B. SUGGESTIONS FOR FURTHER READING

The Lindisfarne Gospels has been the subject of two major studies. The more recent of these is a facsimile edition, *Evangelium Quattuor Codex Lindisfarnensis*, Urs Graf Verlag, 2 volumes; full facsimile, 1956, and commentary (with contributions by T. D. Kendrick, T. J. Brown, R. L. S. Bruce-Mitford, H. Roosen-Runge, A. S. C. Ross, E. G. Stanley and A. E. A. Werner), 1960. This is still the most detailed published examination of any single manuscript. Fewer than 700 copies were printed, and the book is seldom available outside major academic libraries. Still valuable, and certainly more readily accessible, is E. G. Millar, *The Lindisfarne Gospels*, British Museum, 1923. A list of other references to the Gospels, and full bibliographies for the other illuminated manuscripts mentioned in this book, will be found in J. J. G. Alexander, *Insular Manuscripts, Sixth to Ninth Century* (A Survey of Manuscripts Illuminated in the British Isles, vol. I), Harvey Miller, 1978.

A lively and extremely readable general introduction to the history of the period, both social and political, is provided by Peter Hunter-Blair, *Northumbria in the Days of*

Bede, Victor Gollancz, 1976. More specialized information will be found in H. Mayr-Harting, *The Coming of Christianity to Anglo-Saxon England*, Batsford, 1972; *Saint Wilfrid at Hexham*, ed. D. P. Kirby, Oriel Press, 1974; and W. Levison, *England and the Continent in the Eighth Century*, Oxford University Press, 1946.

English translations of many of the original sources for the period are collected in *English Historical Documents, vol. I: c. 500-1042*, ed. Dorothy Whitelock, Eyre Methuen, 1955, second edition, 1979. There are several popular editions of English translations of the most important single source, Bede's *Ecclesiastical History*. A recent and particularly useful one, in which Latin and English are printed on parallel pages, is *Bede's Ecclesiastical History of the English People*, ed. Bertram Colgrave and R. A. B. Mynors, Clarendon Press, 1969. English editions of other major sources mentioned are Bertram Colgrave, *The Life of Bishop Wilfrid by Eddius Stephanus*, Cambridge University Press, 1927, and *Two Lives of Saint Cuthbert*, Cambridge University Press, 1940; C. H. Talbot, *The Anglo-Saxon Missionaries in Germany*, Sheed and Ward, 1954; A. Campbell, *Æthelwulf: De Abbatibus*, Clarendon Press, 1967; and D. Meehan, *Adamnan's De Locis Sanctis* (Scriptores Latini Hiberniae, vol. III), Dublin Institute for Advanced Studies, 1958.

The two riddles cited are taken respectively from Kevin Crossley-Holland, *Storm and Other Old English Riddles*, Macmillan, 1970; and J. H. Pitman, *The Riddles of Aldhelm* (Yale Studies in English, vol. LXVII), Yale University Press and Oxford University Press, 1925. All the riddles of the Exeter Book, in Anglo-Saxon and in modern English, will be found in *The Exeter Book: part II*, ed. W. S. Mackie (Early English Text Society, original series no. 194), Oxford University Press, 1934.

A recent survey of the archaeology of the period is *The Archaeology of Anglo-Saxon England*, ed. D. M. Wilson, Methuen, 1976. Individual objects and discoveries are described and illustrated in *The Relics of Saint Cuthbert*, ed. C. F. Battiscombe, Oxford University Press, 1956; R. L. S. Bruce-Mitford, *The Sutton Hoo Ship Burial: a Handbook*, British Museum Publications, third edition, 1979; and *Treasures of Irish Art 1500 BC – 1500 AD* (the catalogue of an exhibition at the Metropolitan Museum of Art, New York, etc., with contributions by G. F. Mitchell, P. Harbison, L. de Paor, M. de Paor, and R. A. Stalley), Metropolitan Museum of Art and Alfred A. Knopf, 1977.

Most of these books give further bibliography. Recent publications concerning every aspect of Anglo-Saxon history and culture are listed each year in the annual *Anglo-Saxon England*, Cambridge University Press, 1972 etc.

Finally, an unusual practical insight into the type of decoration seen in the Lindisfarne Gospels is offered by George Bain, *Celtic Art: the Methods of Construction*, William Maclellan, 1951 (paperback edition by Macmillan, 1977). Many of the methods described can actually be seen in use in Eadfrith's work.

INDEX